C000070689

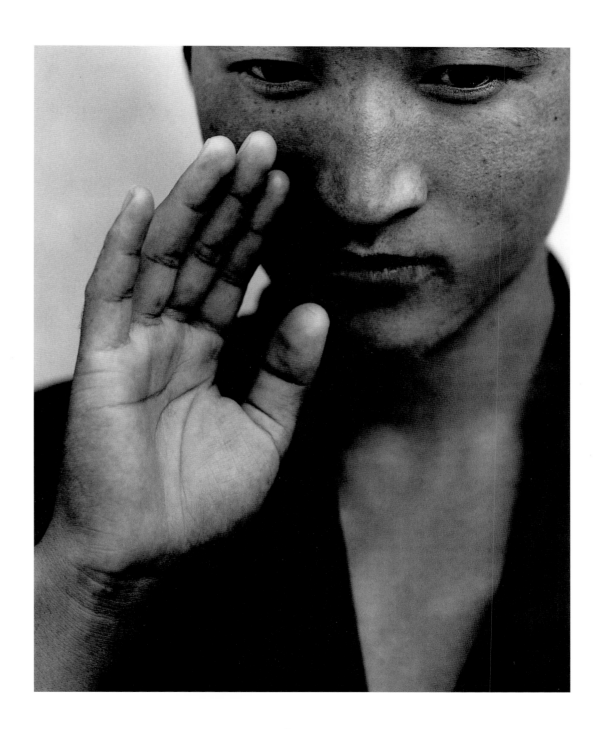

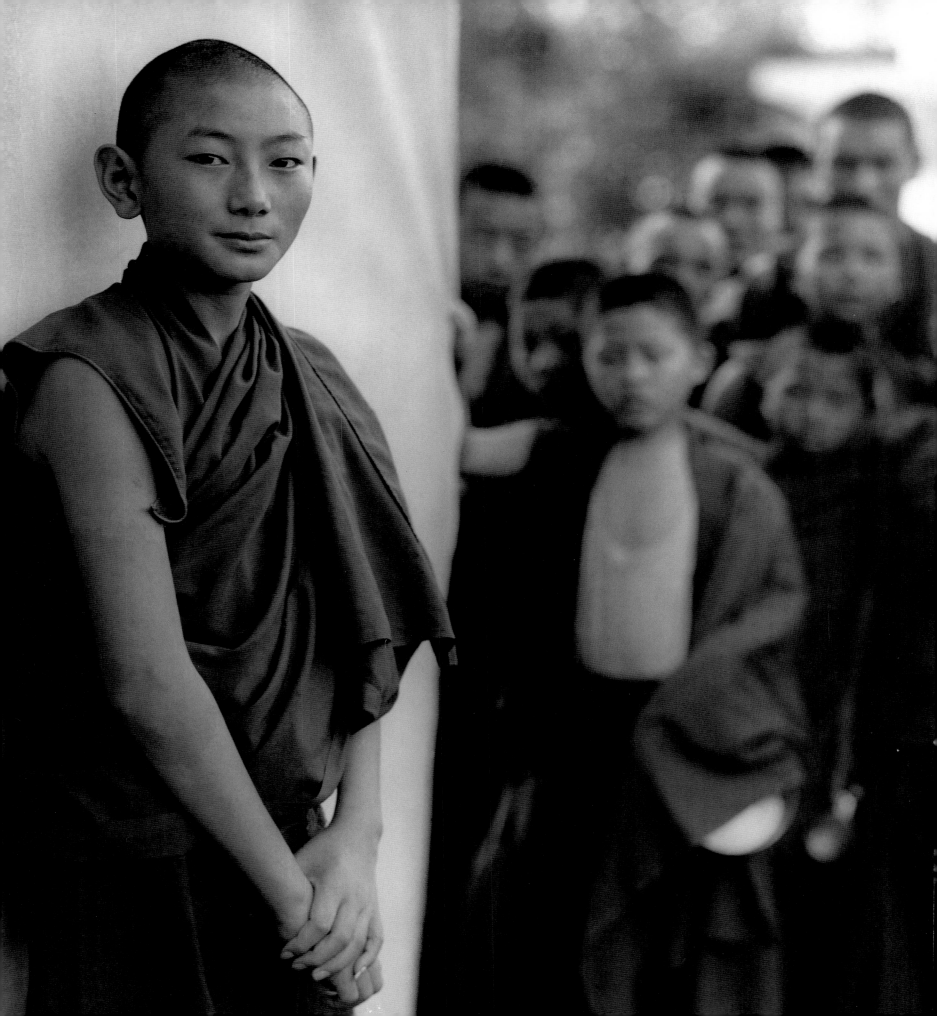

sera the way of the tibetan monk

PHOTOGRAPHS BY **sheila rock**

COLUMBIA UNIVERSITY PRESS

NEW YORK

A percentage of the royalties from this book go to the Sera Jhe
Health Care Committee in aid of various humanitarian projects.

Verses 9, 4, 3, and 22 from *The Thirty-Seven Practices of All Buddhas' Sons*
(*Rgyal-sras lag-len so-bdun-ma*) by Thegme Zangpo, translated by
Geshe Ngawang Dhargyey, Sharpa Tulku, Khamlung Tulku,
Alexander Berzin, and Jonathan Landaw; Library of Tibetan Works
and Archives, Dharamshala (H.P.). Used with permission.

Original signed photographs sold through the Photographers Gallery,
London (www.photonet.org.uk).

COLUMBIA UNIVERSITY PRESS
Publishers Since 1893
New York Chichester, West Sussex
Copyright © 2003 Sheila Rock
All rights reserved

Designed by Brady McNamara

Library of Congress Cataloging-in-Publication Data
Sera Jey Monastery (Karnataka, India)
Sera : the way of the Tibetan monk / Sheila Rock.
p. cm.
ISBN 0–231–12890–8 (cloth)
1. Religious life — Buddhism.
BQ6331.K37 R63 2003
294.3'923'095487 — dc21 2002041259

Columbia University Press books are printed on
permanent and durable acid-free paper.
c 10 9 8 7 6 5 4 3 2 1

sera

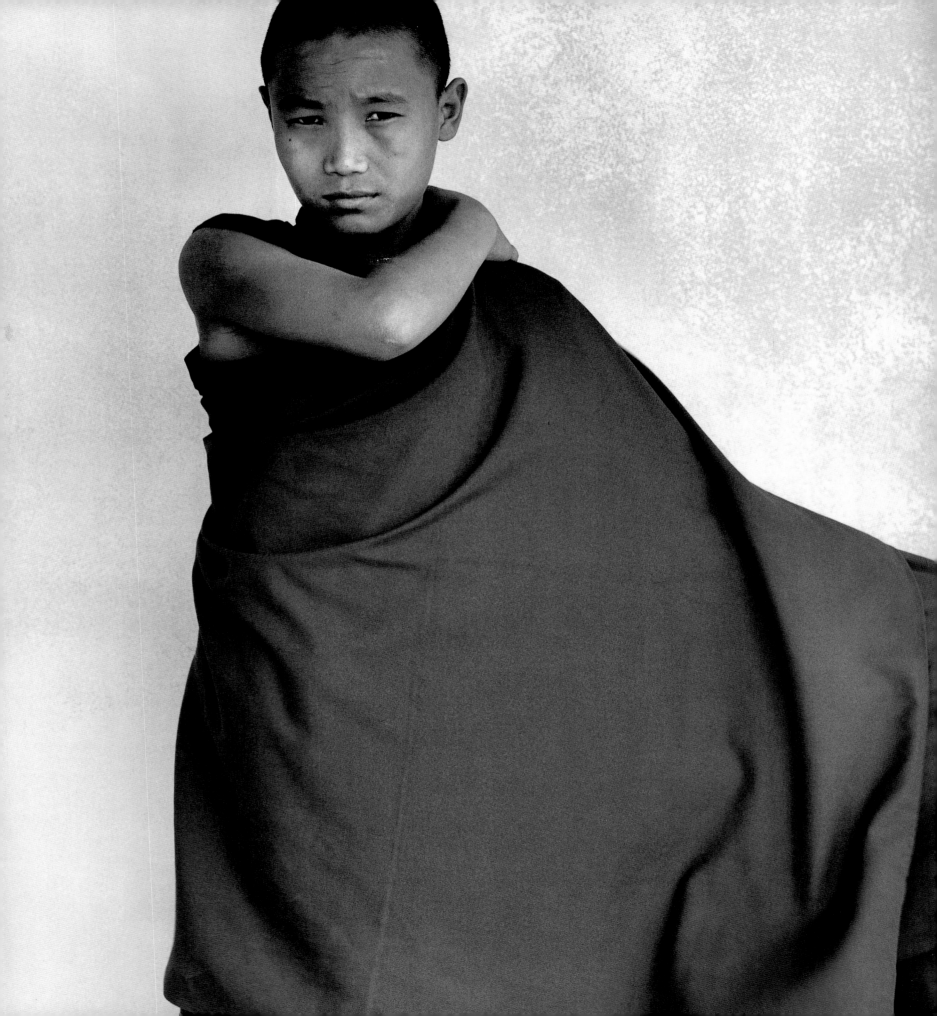

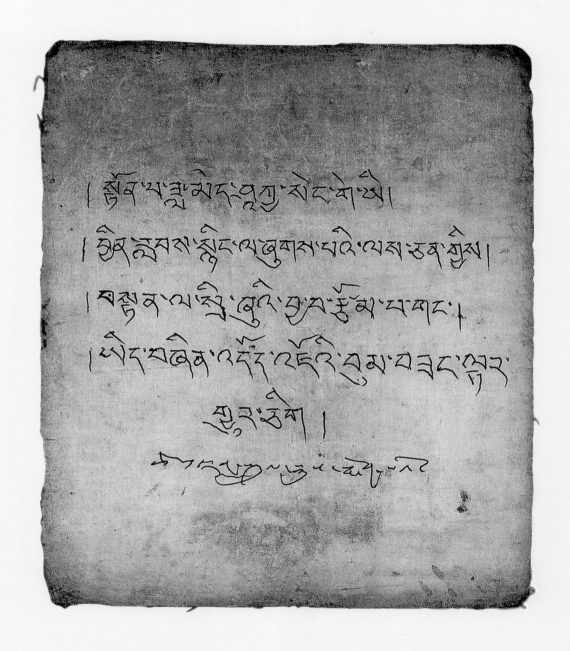

A BLESSING BY CHOEDEN RINPOCHE

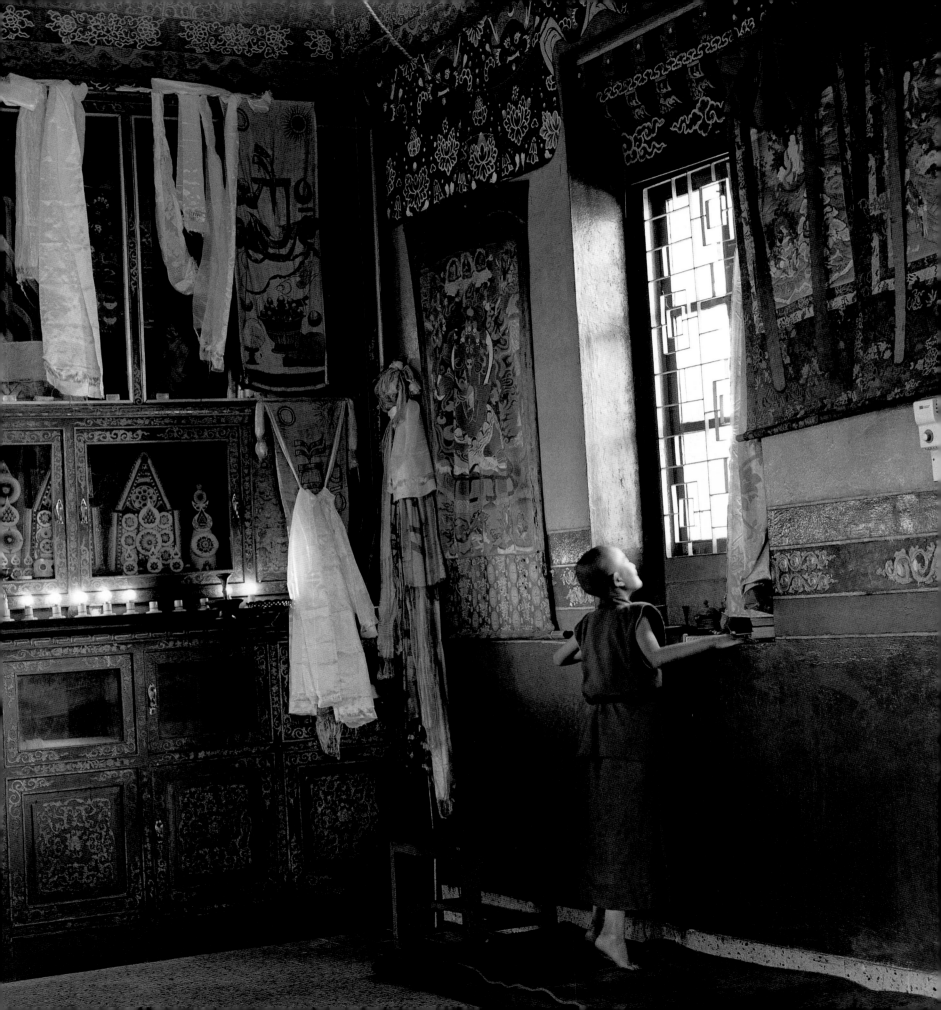

Robert A. F. Thurman

Looking at these beautiful pictures and feeling the pulse of the life of the Tibetan Buddhist monastery, I remember my own years as a young monk in such a place— though during my time in the early sixties the monastic universities were not yet well reestablished in exile. How peaceful and yet full of life is this world of study, prayer, meditation, and being human with a purpose!

A Buddhist "monastery" (*dGon pa*—"sanctuary") is a secure space of physical simplicity and mental ease. You can be intense in study and practice full throttle, and then feel okay about kicking back, relaxing, even playing and having fun. Older monks might pursue a craft, review some complex studies, perform some meditations or contemplative rituals, or receive a visit from lay supporters or relatives. Though the monastery is the institutional response to individuals' renunciation of the "home life" (ordinary pursuits in ordinary cultures), it is not primarily a place of retreat. It is more a community of learning, teaching, and practice of the

evolutionary teaching of the Buddha, the Dharma path of the pursuit of enlightenment. Its textual basis is the Three Collections (*tripitaka*), the Transformative Discipline, the Buddha-Discourses, and the Scientific Treatises on Wisdom. Its daily practice consists of the three spiritual educations (*adhishiksha*), transformative educations in ethics, meditation, and wisdom intelligence (*shila, samadhi, prajna*).

People go into the monastery, leaving behind the pre-occupations, anxieties, thrills, and fears of the worldly life, family and social life, because they come to feel a special sense of the importance of their human embodi-ment, their specially conscious life form. They come to feel this time as a human being is the evolutionary moment of opportunity to explore the self and the world, understand and take control of their life processes in a new way, and transform themselves into higher beings. They decide to become professional "evolvers," full-time students of life and, as soon as possible, certainly

before dying again and facing an uncertain future life, masters of its inner workings. Adventurers on the road to total freedom, they determine to become all-knowing, all-compassionate protectors of all beings—bodhisattvas and ultimately even buddhas!

Of course, in the uniquely and intensively monasticized culture of Tibet, parents introduce at least one of their children into monastic life at an age too young for them to come up voluntarily with a renunciation insight. They remain novices until after their teenage years, and in such a supportive environment, they often do internalize the insights they are taught, and do become genuinely moved by the renunciative impulse not to waste their lives on subsistence trivia but rather to take up the altruistic motive to accomplish something magnificent for all beings. No one goes to a Tibetan Buddhist monastery to be alone, as it is a bustling community. When there is a stage in one's evolution where one must withdraw in order to come to grips with the subtlest workings of mind and body—*reculer pour mieux sauter*—one goes to a retreat hermitage, often far away from the main monasteries. But people at the initial age of entry, the age of many of the subjects in this book, do not consider themselves ready for arduous sustained meditation; they must unlearn an awful lot of physical and mental habits and learn a great deal more about the true, the good, and the beautiful. They are joining a school, a community where everyone shares the orientation toward the transcendent life, the higher ethic, the more powerful mind and deeper meditation, the clearer and more penetrating intelligence, and the all-embracing wisdom and compassion.

The monastery is the core institution of what is called the Jewel Community, which also includes the laypeople who surround it, build it, sustain it, cherish it, enter it, and enjoy it. The inner focus of the minds of the people in it radiates outward to the larger society a sense of calm, happiness, safety, purposefulness, and meaningfulness, and strong feelings of life fulfillment and unlimited potential. It is a jewel of a community because it is rare and precious in the world of egotism, competition, stress, violence, and mindlessness, from all of which it is a jewel of refuge. When people live in it or even just visit it, their cares tend to melt away. Their deep anxiety about their place in the world, their uncertain future, their fortune or misfortune in life, their looming death and afterdeath, and the great unknown of their after-life—all this temporarily leaves them and they feel safely harbored in refuge with friendly companions, perhaps protecting spirits, deities, angels, and even buddhas, whom they impersonate seasonally in sacred dances and public ceremonies and pageants. The Jewel Community helps them feel in touch with their own inner refuge, the Dharma within their own being, their own usually ignored or taken-for-granted unity with the ultimate reality taught by the buddhas, the overriding reality of natural freedom, peace, and blissfulness. The Jewel Community is the engine of the morphic resonance (socially transforming mind-to-mind vibrations) of upward-striving minds, sensitive and friendly hearts, and the relief of unfolding limitless potential for freedom and all-encompassing positive presence.

This is why Tibetans love their monasteries; why, against all expectations, the first thing they did in Tibet when

granted temporary free rein in 1980 after the end of
Mao Zedong and the "Gang of Four" was to turn
voluntarily to the civil disobedience of starting to rebuild
their 6,254 ruined monasteries; and why, against all
economic odds, in their exile communities they have
persisted in making it possible for the amazingly high
figure of more than 15 percent of their population to
enter and develop spiritually in monasteries.

Outsiders expect a Buddhist monastery to be all serious
and even mournful, as if the inhabitants had died to
the world and gone into some zone of morbid self-
flagellation, abusing themselves, denying themselves in
hopes of achieving either some sanitized bliss or resigned
obliteration. This is a complete misunderstanding of
what is a Buddhist "residence" (*vihara*) of the renunciate
Jewel Community. In fact, a Buddhist monastery is a
distinct institution, rather different from the Christian
institutions in the West from which we get the word
"monastery." The reason it is hard for westerners to
imagine what goes on in a Buddhist monastery is
that even the words "monastery," "monk," "nun,"
"renunciation," and "ordination" come from the
Christian, western context. The Buddhist institution has
a different source and operates in a different context.

The Buddhist institution is actually the original, arising
during the mid-first millennium B.C.E.; the Christian
one evolved almost 800 years later, very likely with
some influence from India, but adapting to very different
ideological and social settings. When the Shakyan
prince Siddhartha left his wife, child, father, foster
mother, throne, subjects, and royal profession to seek

the meaning of life through introspective investigation,
he joined a *de facto* brotherhood of unorganized
wandering ascetics (*shramana*). They were not numerous;
lived in the wilderness in extremely hard conditions;
were feared but tolerated by the wealthy Indian society
that had space, food, and manpower to spare; and were
led by the occasional seeker who had found something
transformative. For all this, they were respected as
sages, holy men, and teachers.

The prince himself spent six years in this way of life
and exploration before rejecting also the profession of
asceticism. He attained a new understanding of reality,
internal and external, that transformed his own life, body
as well as mind, and also transformed his understanding
of the meaning and purpose of life. He then established
a new community, which he structured gradually and
adaptively, in interaction with the larger society. He
declared that this was the way such Jewel Communities
were organized, whenever any buddha arose in the
world (he said there were many buddhas, already three
before him in this world-cycle alone, another 995 to
come). His new Jewel Community was neither a
community of worldlings nor a community of ascetics.
It was a community of seekers, individuals, women as
well as men, who sought to awaken from the habitual
human condition, to become free of human perplexity
and impulsive drives, to develop their full capacities for
understanding, in order to become in that very life
completely free of suffering for all time. These individuals
lived by daily begging and so were called "mendicants,"
bhikshu or *bhikshuni* (not "monks," from the Greek *monos*,
meaning "alone"); wore uniform robes of patched-

together cast-off cloth dyed a cheerful saffron orange; ate only one meal a day before noon; renounced sexuality, property, violence, and pretension; and lived in simple shelters in open common spaces on the outskirts of cities and towns, rather than in remote wilderness.

The Buddha, now called Shakyamuni, accepted an individual into his community simply by saying, "Come hither, mendicant!" ("*ehi bhikkhu*"), at which point the aspirant's hair would instantly disappear and her or his clothing magically would be replaced by the saffron robe. During the course of his forty-five-year teaching career, the Buddha established two or three hundred rules governing the most minor matters of verbal and physical behavior, also authorizing the mendicant community itself to continue the refinement and adaptation of the body of rules to function effectively in future social contexts. He judiciously established a discipline (*vinaya*) of self-restraint that created the foundation for the strenuous enterprise of moral, mental, and intellectual transformative education that was the overriding occupation of the individuals in the community. The discipline also provided for the education of a special lay community that took on a lesser level of practice but supported the renunciate mendicants and mediated their relationships with the larger society.

This community was from the beginning expressly identified not as religious but as educational. All priestly activity was prohibited for the mendicants. They were not allowed to name babies, perform weddings or funerals, function as diviners or psychics, or hold prayer services. They were not to compete with the powerful Vedist priests, the brahmans, in their profession, not to threaten their livelihood by forming a rival body of religious officiants. The mendicants could accept alms food once a day from the laity, cloth once a year, and could give them teachings on the topic of the liberating Buddha Dharma, if requested—but perform no religious services. Members of the community joined because they found faith that the Buddha himself had awoken to the true meaning of life and attained a true liberation, and that they could do the same by understanding and implementing his teaching. The Buddha forcefully taught that they could not awaken or attain liberation just through faith, but rather would need to engage in transformative action, meditation, and learning and insight.

Therefore, the cardinal principle of the Buddhist movement, renunciate and lay, was freedom and enlightenment (not obedience and worship, as in the later Christian monasteries). The practice was the educational quest of liberation from suffering and wisdom enlightenment through knowledge. It was not religious in the senses of observance of ritual routines and cultivation of belief in the saving grace of a deity. The mendicant's renunciation of conventional human occupations and attitudes was not to deny the self as a penance or purify the self to receive grace from a deity. It was to reclaim the deepest energies of life from the normal social routines of the culture and to dedicate them to self-transformation of body, speech, and mind, in order to evolve into a superhuman being free of inherited ignorance, instinctual self-centeredness, and the impulsive drives of lust, hate, envy, and pride that all together constitute the root of human suffering.

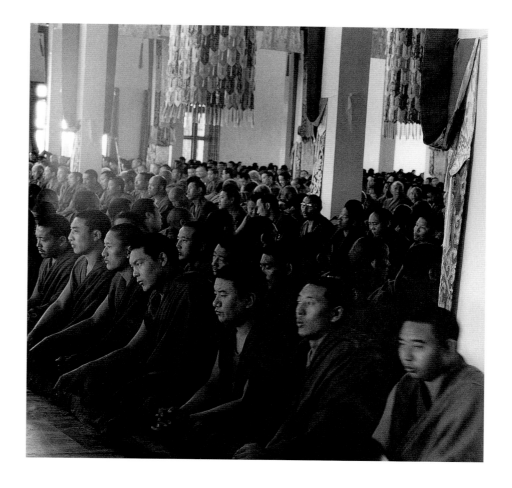

The language in which the Jewel Community expressed its mission was drawn primarily from an inversion of military expressions, with a certain sprinkling of business metaphors. We must remember that the Buddha would have been a king, a "commander-in-chief," had he stayed in the home life of his culture. Awakening results from the conquest of an "inner enemy," the education for it is a kind of "training," "discipline" is required, a Buddha is a "victor" (*jina*), and so on. Mendicants shave their heads, wear a nonindividualistic set of robes, have minimal possessions, live with a heightened level of introspective vigilance and interactive alertness, and confront the realities of death and suffering, like soldiers trained for military ventures.

It is also a fact that the progress of the Buddhist movement in country after country resulted in a trend toward demilitarization in society after society, though this was almost never complete—perhaps most complete in the cases of Tibet and Mongolia. There is an important insight here: the militant antimilitarism underlying the Buddhist monastic institution (in some sense, all monastic institutions) gives an unexpected global perspective on the history of societies in this world. An inverse equation can be made between the degree of monasticization and the degree of militarization. A totally monasticized society becomes incapable of militarism. A totally militarized society becomes incapable of monasticism. The two universalizing institutions form counterweights

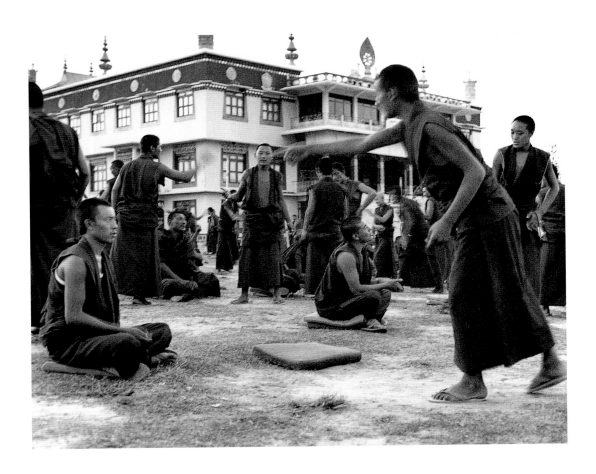

to each other, and the history of a particular civilization can be traced as a seesaw alternation of prevalence of one or the other.

Tibet was definitely the most monasticized civilization in history. All scholars agree on this, some deploring it, some applauding it. It evolved over a thousand years from a militaristic Central Asian empire into a demilitarized, politically vulnerable state. America today is the polar opposite, pre-Reformation monastic institutions having become merely vestigial, and the whole society and economy almost entirely directed toward militarism, as the last great "superpower." This has real bearing on our fascination with Tibet, it being our image diametrically reversed in the mirror of history.

Looking at the young monks in the pictures, we can imagine them in another kind of uniform, as young soldiers in training for battle, playing fighting games like the sports in our schools: wrestling, tackling in football, wielding sticks in hockey and lacrosse, running and feinting and jumping in basketball. This helps us appreciate how their energies are being shaped in other directions.

⁂

The Buddhist Jewel Community's "conquest," or in their own parlance "taming" (*'dul ba*), of Tibet, its gradual replacement of Tibet's military culture and institutions, took approximately from 640 c.e.—the building of the

Jokang Buddhist temple in Lhasa—to 1640 C.E., the building of the Potala above Lhasa. This monumental palace (largest in the world) incorporated royal fortress and government seat, monastic residence and spiritual monument, and celestial mandala palace in one imposing, mountainlike edifice, named after the "pure land" of the Buddhist messiah, the celestial bodhisattva Avalokiteshvara. The thousand years of nation-taming was not at all easy or natural. When Buddhism was brought into Tibet by the conquering emperor Songzen Gampo (597–649 C.E.), the feudal warlords under his rule thought of it merely as a more powerful magic of temples and priests, and it took almost 150 years for the first monastery to be built and supported. The values of Buddhist nonviolence, evolutionary education, selfless wisdom, and universal compassion were completely opposed to the martial values of the empire: conquering violence and cruel exploitation of those conquered, martial training and obedience, absolute dedication to the nation and its deities, and ruthless treatment of animals, women, and foreigners. Soon after transcendental monasticism was introduced, the military empire fell apart, and it took further centuries of many individuals' efforts to introduce the monastic way of life and spread its evolutionary curriculum and the nonviolent, universalistic, and liberative values of the Buddha Dharma throughout the society.

An important milestone in this glacial progression was the civilizational renaissance inspired by the life, attainments, and works of Tsong Khapa (1357–1419). A renunciate monk since childhood, he studied widely and intensely for 35 years and then spent six years in arduous retreat.

At the age of 41, in 1398, he is thought to have attained complete enlightenment. He then began a 21-year career of major public works of celebrating, teaching, and institution building. His fame spread throughout Tibet, Central Asia, and even Ming China. Huge assemblies of monastic and lay students assembled to hear his teachings and celebrate the visionary festivals he and his close followers began to stage. In 1409, he founded the Great Prayer Festival in Lhasa, a New Year's pageant and two-week-long religious holiday, celebrating the Buddha's triumph over rivals in ancient India. In that same year he founded Ganden Monastery, now a few hours' drive from Lhasa, which eventually became a monastery of 5,500 monks. Then in 1416, his close disciple Jamyang Chojey founded Drepung, which had 12,000 monks at the time of the Chinese invasion in 1950. Another important disciple, Sakya Yeshi (1355–1435), established Sera Monastery, even closer to Lhasa, in 1419, at a site made auspicious by its having hosted several of Tsong Khapa's retreats, during which he composed his most famous philosophical work on selflessness, the *Essence of True Eloquence*.

The force of Tsong Khapa's charismatic movement was so great, oriented toward the advent of the future Buddha, Maitreya, as much as toward the past Teacher of Humans and Gods, Shakyamuni, that there were many disciples who wished to enter the mendicancy and the evolutionary curriculum. These three great monasteries around Lhasa together swiftly grew to hold a monk population larger than the normal population of Lhasa city, which was around 20,000 at that time. During the Great Prayer Festival at the Tibetan lunar

new year in February or March, the monasteries would take over the town, and several hundred thousand people would converge on Lhasa for two weeks. Symbolically, at least, the whole nation's capital became a monastery during that period each year, indicating in principle that any Tibetan had access to the evolutionary lifestyle and the higher attainments it could provide. I call this time at the turn of the fifteenth century the Tibetan Renaissance, as it was the explosion of millennial consciousness in the Tibetan mind, a sense of evolutionary fruition, inspired by the vision that real freedom from one's own suffering and the indomitable bliss of omnicompetent compassion for others were accessible in principle to all, here and now.

The main point in this context is that this moment in Tibetan Buddhist history witnessed the birth of Sera Monastery, the place depicted so intimately and luminously in Sheila Rock's portraits. Though it was partly demolished and largely trashed from 1951 to 1981, the first 30 years of the Chinese occupation of Lhasa, Sera Monastery still stands today. In 1950 it had around 8,000 monks; today it has a few hundred, and those are under severe constriction of supervision by Communist thought-control committees. In the main debate courtyard, there is a famous boulder, enshrined in a small structure. Legend has it that, to the astonishment of all present, the eloquent verses of transcendent wisdom that describe the 16 voidnesses swirled gloriously through the sky in golden syllables written in Sanskrit letters and then dissolved into the rock. It is therefore considered highly auspicious to critically reflect in debate and meditation on the profound import of the nature of ultimate

reality around that rock. In a sense, the monastery was built around the rock, as the curriculum was built around the rock of transcendent wisdom, the transformative insight into absolute selflessness of subjects and objects reached at the summit of critical reasoning and contemplative concentration. In this legend, we see the fusion of mythic imagination and analytical discernment that is the hallmark of the Tibetan Buddhist tradition.

The tremendous power of that vivifying fusion is perhaps the secret underlying the remarkable sociological fact that Sera Monastery, once already dead and then revived, but barely, under Chinese suppression in its home site in Tibet, now lives and thrives in exile in Mysore state in southern India. Although the pool of candidates is now no more than the 150,000 or so Tibetan refugees, including the few hundred especially strong-minded and brave souls who were able to escape in thin sneakers across the high Himalayan passes in winter to reach their free university, Sera is still filled with thousands of intensely striving young seekers. There are now between 4,000 and 5,000 monks in the two main colleges, Sera Mey and Sera Jey. They are so happy to be there. They feel so privileged to have that education, to dive into that curriculum.

There is a tendency on the part of American observers of Tibetan monks to think of them with sympathy— "The poor dears! So adorable and cute and bright and energetic, and yet so bereft and forlorn." Some of the portraits here presented could be seen wrongly in that way. Of course, the monks and their lay supporters in the surrounding community are refugees, and so are

lean and awake, their glances filled with that extra intensity. But it is not an intensity of longing for some worldly goods, for some worldly success. They have long seen the illusoriness of such ephemeral things. They are longing for buddhahood, longing only for full clarity of insight, serene calm and unshakeable stability of mind, the higher bliss of enlightenment and the beauty of the buddha world. They have lost their country, many have lost their families and friends, yet they are thriving on professional "homelessness" and are prepared to take advantage of these disasters. They learn to experience them as foreshadowings of the nature of life and death, to use the shock and horror they inspire to intensify their critical energy so they can reach a level of being wherein they can feel free of any loss, recover everything essential and more, and on top of that, restore all loss and mend all grief for all other suffering beings.

Of course, not all of them are so focused all the time. They can even relax and feel calm about their inevitable progress, as they feel themselves mounted on a great vehicle that is moving them toward their goals. They look at you as one who can also be taken up on that vehicle, should you so choose. They see you in so many ways: as a potential corpse, your physical appearance to them not the real you, just your temporary vehicle that will soon deteriorate and be left behind at death; as their mother of many past lifetimes, one of the "mother living beings" they constantly pray for—therefore, as their family member, their nearest kin, they see you with the familiar intimacy you see a family member; and as an extraordinary human being, with the wisdom intelligence that can, if properly developed and directed,

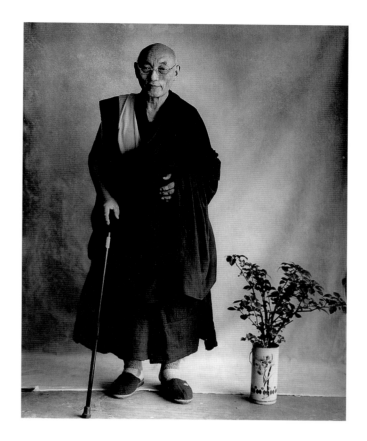

understand the very nature of all reality and attain full freedom from suffering. To this one they perhaps look with challenge. "Why do you run around that way? Why do you not change your life? Why do you waste the precious resources of your intelligence and your sensitivity? Will we have to meet again and again, life after life, as we have met so many times before, driven by evolution, still staring onward and outward and toward the future in bewilderment and fear? Will you just step back, look within, be critical of your programs, seek and find what you really want where it really is, right there within and around you?"

Perhaps Sheila Rock felt the power of these questions, posed to her in these faces, as she was enfolded in the atmosphere of this ancient theater of inquiry into the deepest matters, the "great matter" of life and death, of

endless, unnecessary bondage and ultimate, infinite liberation. This drew her back again and again. She opened the lens of her camera, the gateway of her artistic sensitivity, the doorway of her heart. And so her luminous pictures focus on the clear light at the heart of the life of this ancient monastery; they bring it to you as nondually illuminating the cracks and crevices of the homeless home, the absolute relativity of faces and masks, bodies and objects, rooms and shrines. To visit with her pictures is to enter this sacred yet lively space, sublime yet earthly realm, human yet divine serenity, ordinary yet extraordinary intelligence and sensitivity.

Welcome to Sera Monastery! Welcome to the Jewel Community! Welcome to the living Buddha's great vehicle! Take comfort in the living intellect of gentleness, the realism of compassion, the durability of wisdom! May all be inspired not to waste their, or anyone's, precious human life form! May all have good fortune, encounter the opportunity to achieve their own highest potential, and take advantage of it to make their lifetime count!

Let me close by translating the sole inscription photographed by Sheila Rock.

May those who have the evolutionary fortune
To feel in their heart the blessings of the Shakya Lion,
The Peerless Teacher (Shakyamuni),
And who undertake to school themselves
In His liberating teaching—
Become good vessels of wish fulfillment
For themselves and all other beings!

ROBERT A.F. THURMAN
COLUMBIA UNIVERSITY, DECEMBER 14, 2002

Sheila Rock

I've always felt that we are on a journey of self-discovery—becoming a free spirit and following my heart has been something I've tried to do all my life. It has led me to many wonderful places and meetings with many interesting people around the world.

I have always had an interest in eastern spiritual ideas. In 1998, I traveled to India and Sri Lanka visiting spiritual places, many that I had read or dreamed about as a young girl.

I remember the first time I arrived at Sera Jey Monastery. It was nearly sunset, and from a distance I could hear the most compelling and haunting sounds from the main temple—a chorus of monks' voices in ritual chant humming like a hive of bees buzzing. Inside the temple, which was decorated in bright colors and ornate ritual flags, sat a sea of monks in saffron-colored robes—2,500, I guessed—chanting their sutras. It was both beautiful and awe inspiring at the same time.

I'm not sure if it was at that moment that I felt it was part of my destiny to become close to these Tibetan monks, but it was certainly one of those magic moments that leaves a lasting memory.

Here at Sera Monastic University, one of three great monasteries near Lhasa, Tibet, and now reestablished in Karnataka, South India, there is a community of Tibetan monks living a life of devotion to the Dharma practice. There is a strong sense of traditions being handed down from one generation to the next and a reverence for those traditions. I saw that worldly possessions have little value in themselves and love and fulfillment is found in monastic observance. I found ascetic life inspiring. I embraced the strength of innocence and enjoyed the calm and tranquility of this special place. I was moved by the monks' openheartedness and felt compelled to capture the light in their faces.

The following year I returned to India. Initially I thought to do a series of studio portraits using the same

techniques and equipment I have been using for my usual commercial work. I brought a small background that I carried around with me and invited monks to be photographed behind temple walls. On other days I would take the opposite approach and would watch for chance moments. I would move freely and seemed to blend in with the environment almost unnoticed.

Sometimes I would ask to photograph the monks in their room, where the living conditions are far removed from western life. Monastic accommodation is generally very simple: often a very small room with a single bed,

a few books, and maybe some postcard images of the Himalayas or landscapes from Tibet.

I hired a young Tibetan student called Tashi who studied *thangka* painting, the traditional religious painting from Tibet. I taught him to load my Hasselblad and to take light readings. He acted as a translator and sherpa, and we made a good team.

I decided to shoot all the images in black and white. Often color can detract from the communicative power of the picture and our eyes become interested in the

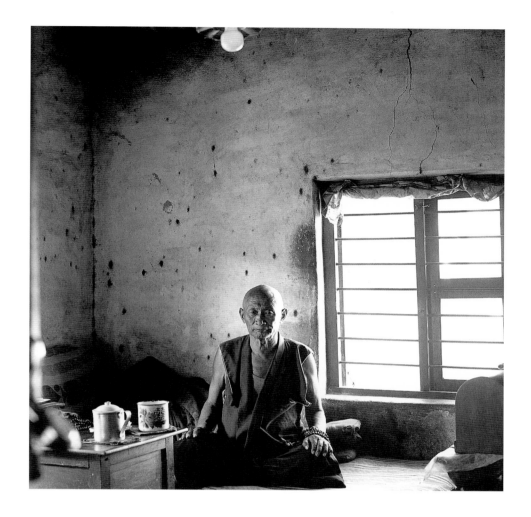

saturation of color rather than the strength of the image. The vibrant red robes would take away from the sensitivity of the faces, I felt.

The robes intrigued me. I admired their simplicity and found that there was a lot of symbolism attached to them. Each piece of clothing seems to represent an aspect of the monks' Buddhist beliefs. For example, two pleats of a monk's skirt facing each other represent compassion and wisdom and the realization of reality. The yellow cord holding up the skirt is the color of Buddha's wisdom.

The red robes are usually worn and have many functions. Formally the robe is worn leaving the right shoulder bare and is very elegant. In cold weather it is worn as a blanket for warmth, and in the hot sun it is a hat for protection from the heat.

In the visits that followed I was introduced to many inspired lamas, including the wonderful Choeden Rinpoche and the teenage lamas, Venerable Osel and Gomo Ladang Rinpoche, both reincarnations of great lamas from Tibet. And it was in Drepung Monastery, several hours from Goa, that I had a special audience with

His Holiness the Dalai Lama. It took place in a large, impressive hall; at the end of the room, His Holiness was waving and smiling for me to come closer. I showed him Polaroid examples from some of the shooting and he was wonderfully supportive. His Holiness wished me much success and spoke of the importance of keeping the Tibetan culture alive and in the minds of all people. We shook hands, but when he touched my hand he gave it a most heartfelt squeeze. An unforgettable connection.

I am excited about each and every person photographed in this book. From each one shines their inner life, and it is their spirit that has created this body of work. In humble gratefulness I thank all the monks of Sera Jey, Sera Mey, Drepung, Kague, Namdroling, Zongkar Choede, and Tashi Lhunpo monasteries. A special thanks to Geshe Ganden Gyatso for his organizational skills and his wonderful advice and bountiful energy.

I appreciate all the tutoring and *puja* invitations from the Italian monk, Massimo Stordi, and I so value Geshe Jhampa Choezin's shy ways and sweet nature.

Many thanks to the Sera Jhe Health Care Committee for their good work and nurturing. I am honored and thankful for the blessing of the venerable Choeden Rinpoche and the meeting with His Holiness the Dalai Lama, which I will always remember.

I thank my assistants Tashi Tsering and David Crooks for their wonderful support, and Steve Walsh for his darkroom artistry. Kindest thanks to writer and friend, Henry Flesh, and my editor, Wendy Lochner, who both had the vision to see this as a book. Many thanks also to Terence Pepper, Geoff Waring, Maryse Vassalo, Philippe Achard, Terri Manduca, Roger Deakin, June Bateman and Tibet House U.S., Bruce Mitchell, Elaine Milligan, Yuriko Kishida, Helen Walker and Carla Pozzi at Studio Immagine for their helpful words of support. Deep thanks to Robert Thurman for his illuminating words, and to Theresa Leong, who foretold my meetings with these remarkable men. It is important that spirit and art become one, she said. Finally, I wish to thank my friend and partner, Andrew Sanders, for his keen sense of adventure and innate sensitivity, and for sharing so much of life's journey with me.

from

THE THIRTY-SEVEN PRACTICES

OF ALL BUDDHA'S SONS

Withdrawing completely from things that excite us,
Our mental disturbances slowly decline
And ridding our mind of directionless wandering,
Attention on virtue will surely increase.
As wisdom shines clearer, the world comes in focus,
Our confidence grows in the Dharma we've learned.
Live all alone far away in seclusion—
The Sons of the Buddha all practice this way.

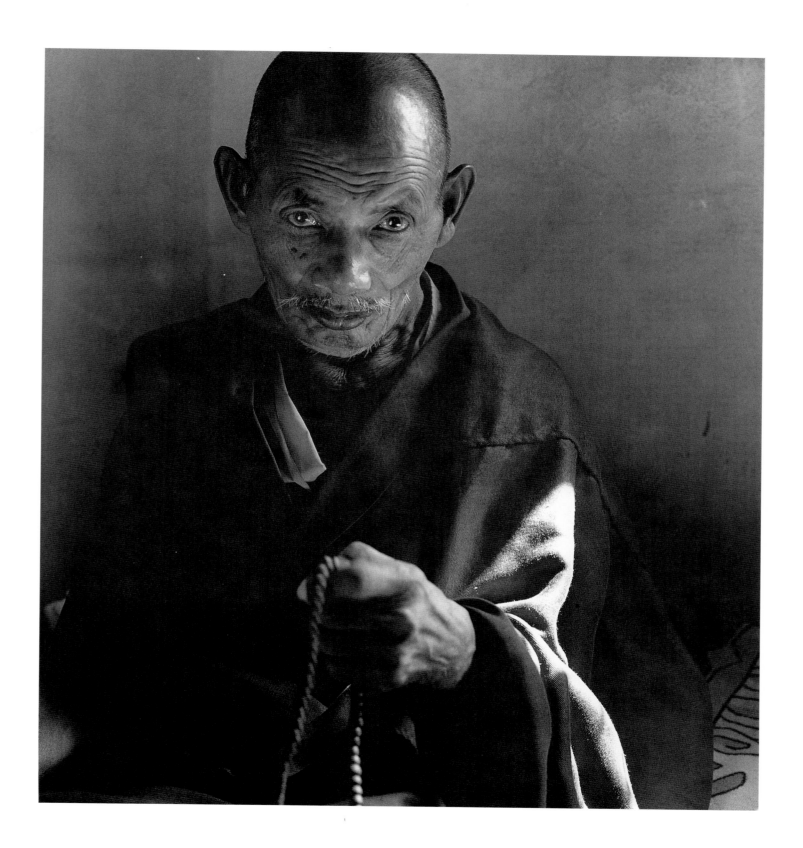

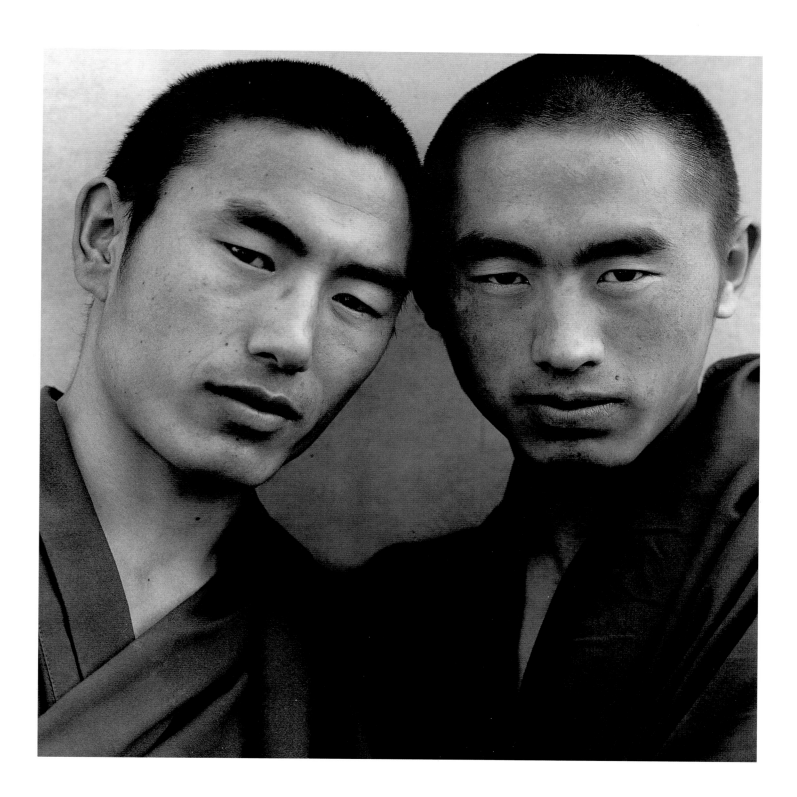

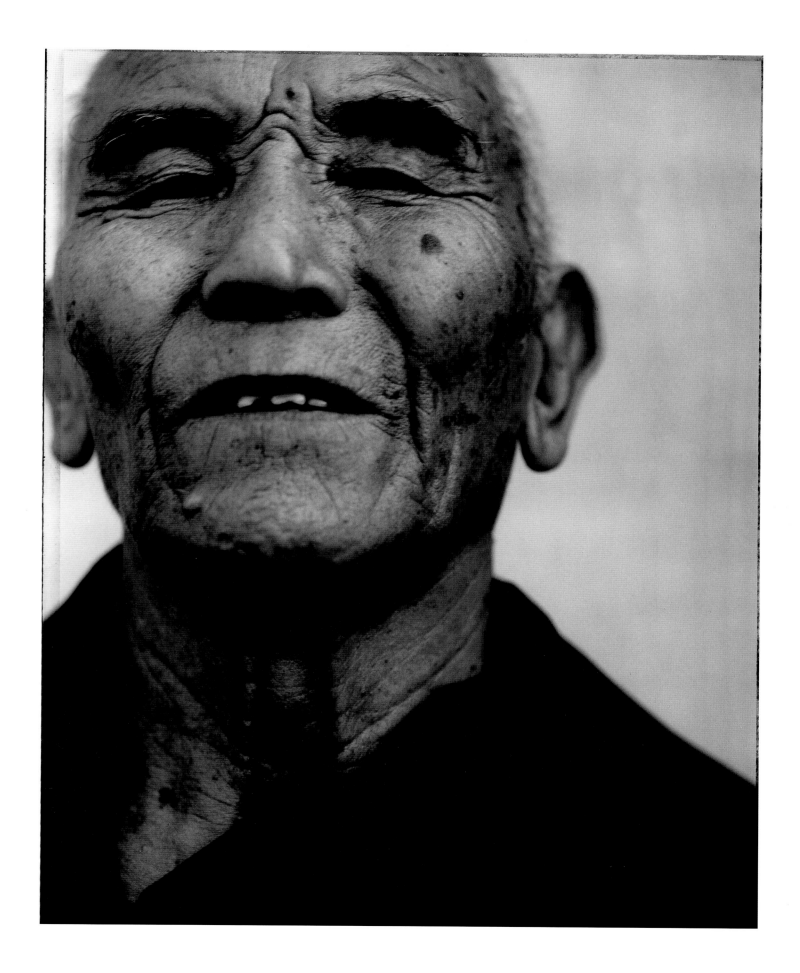

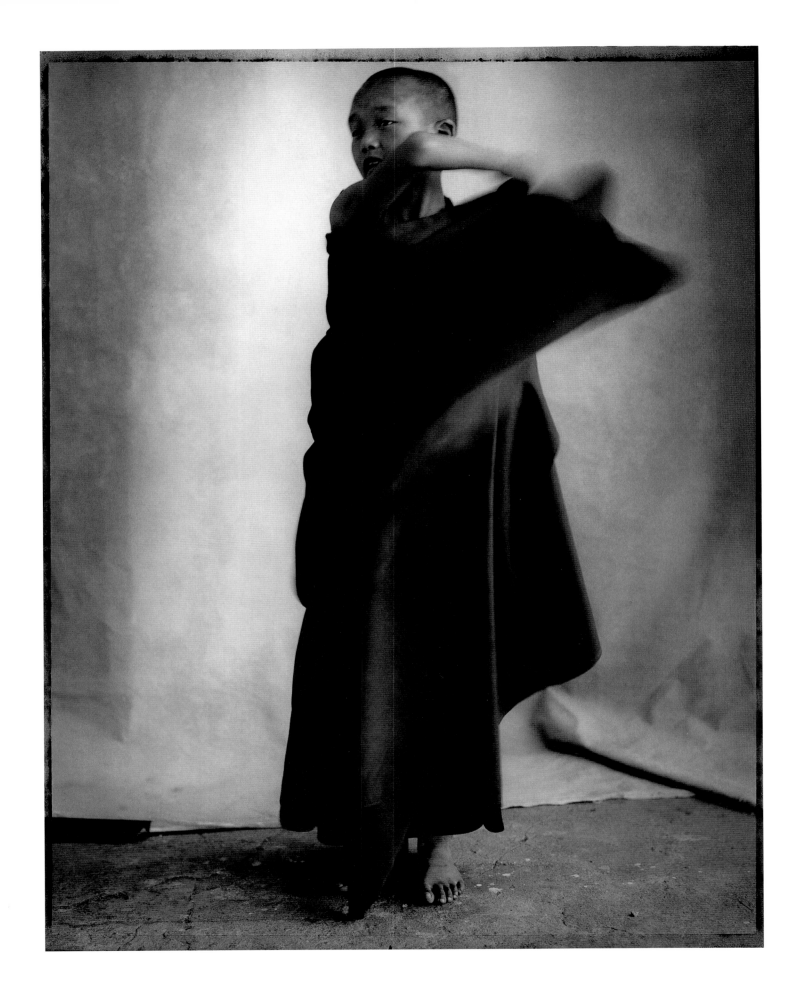

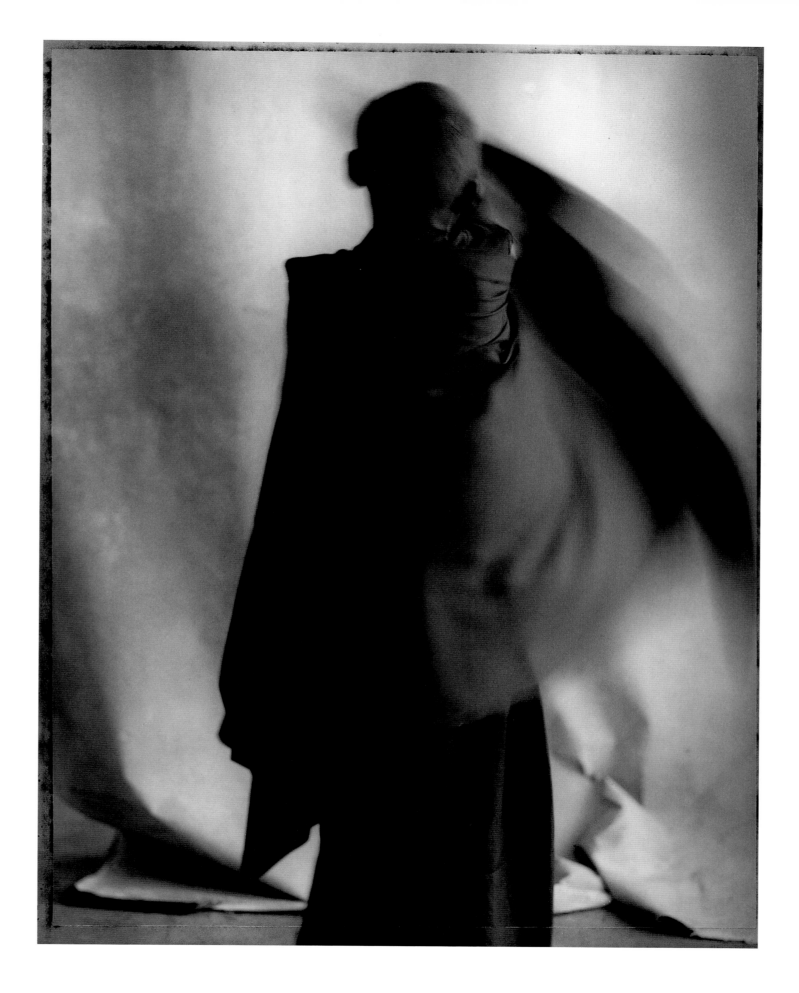

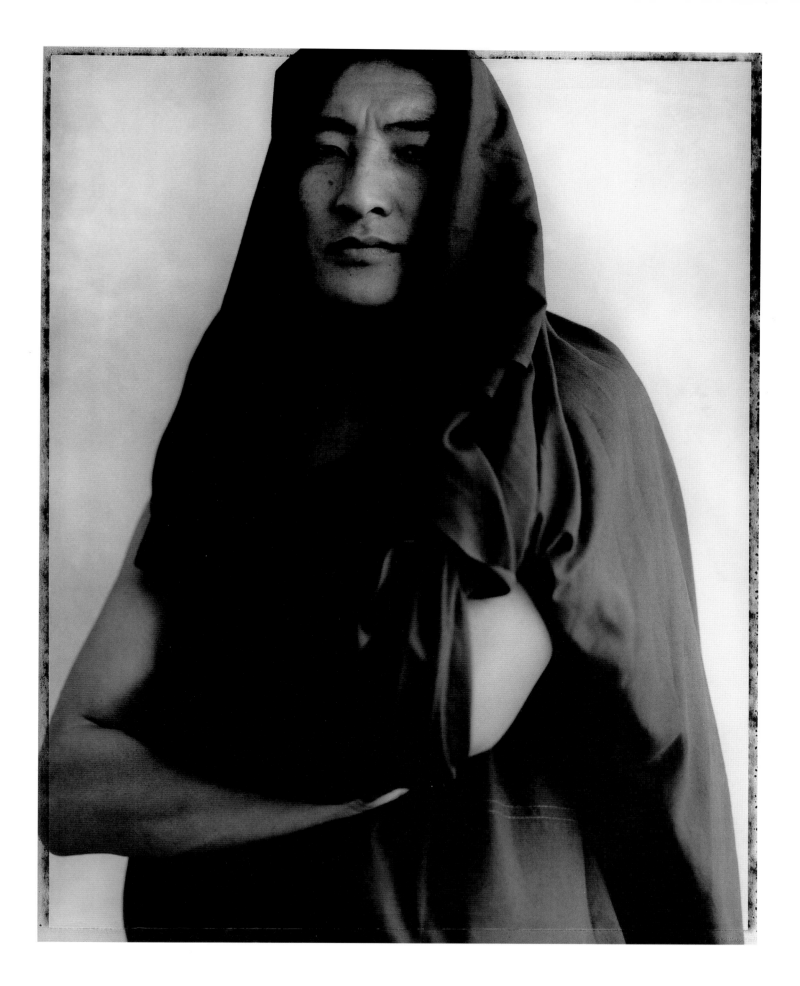

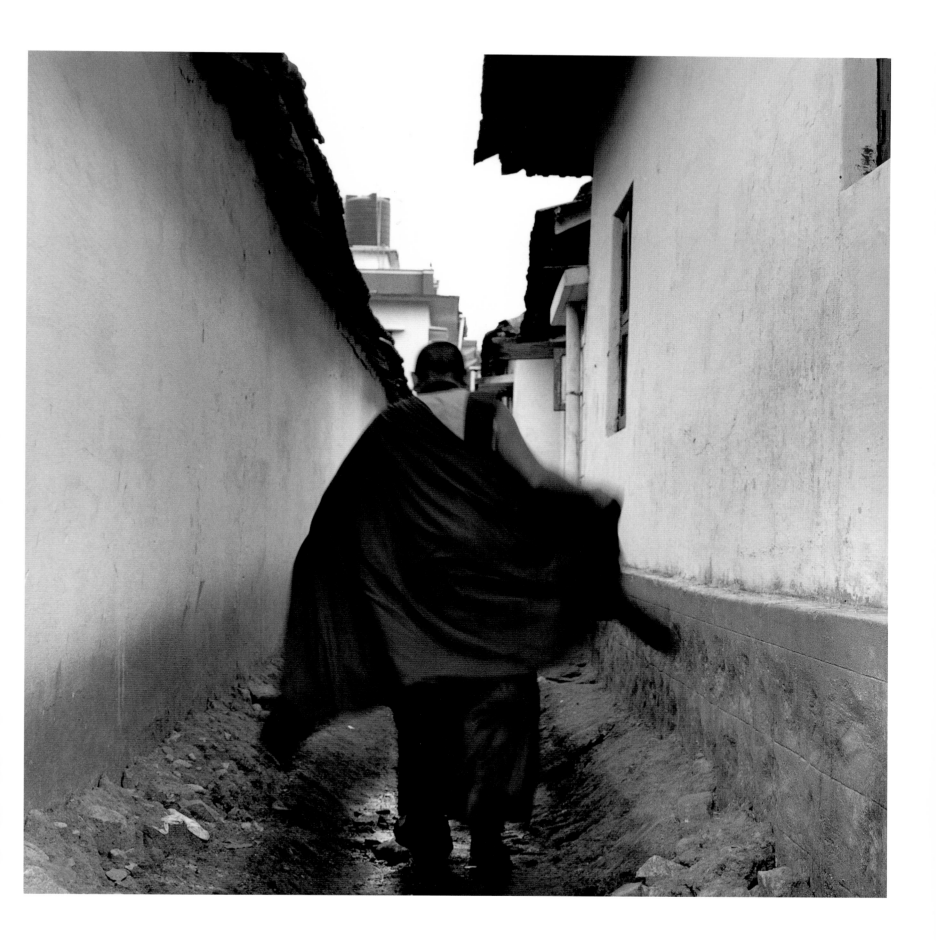

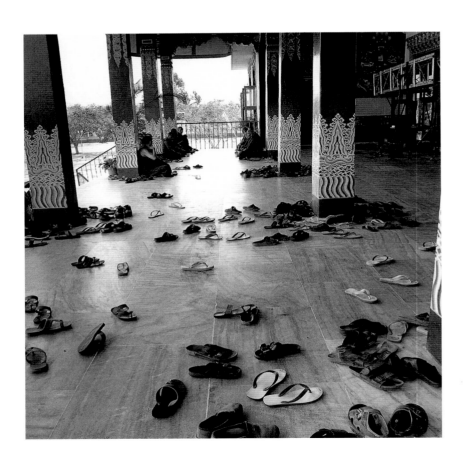
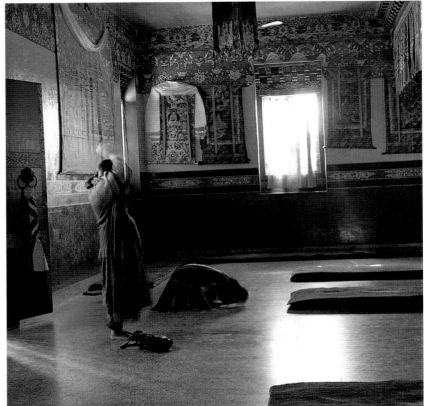

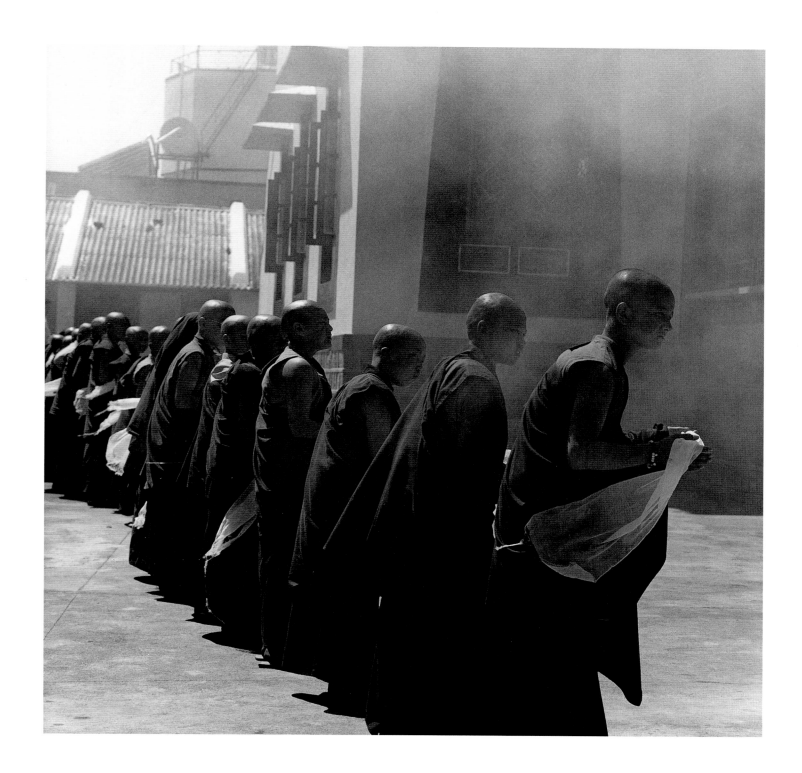

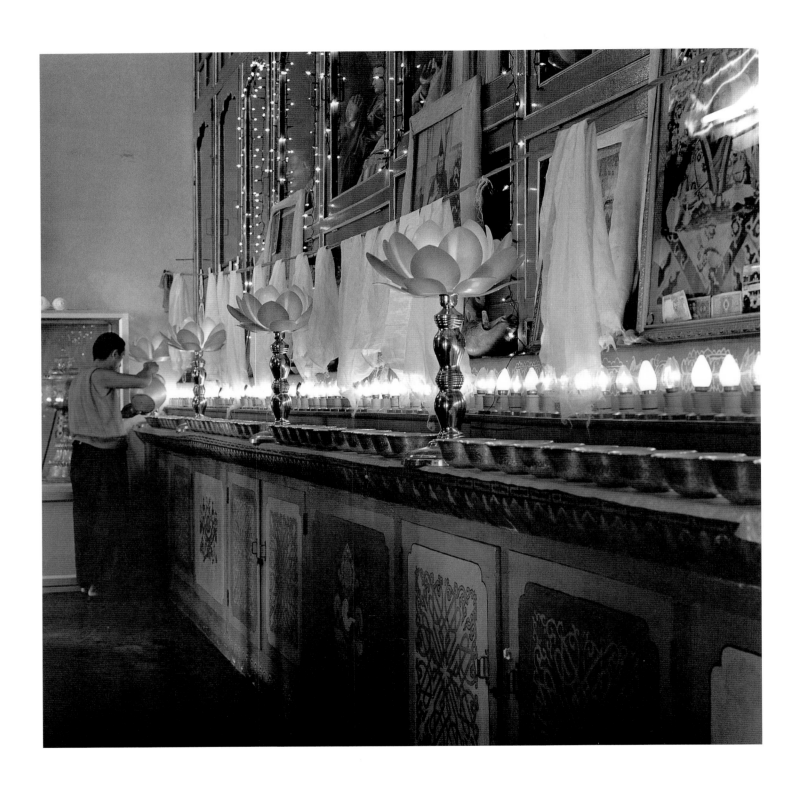

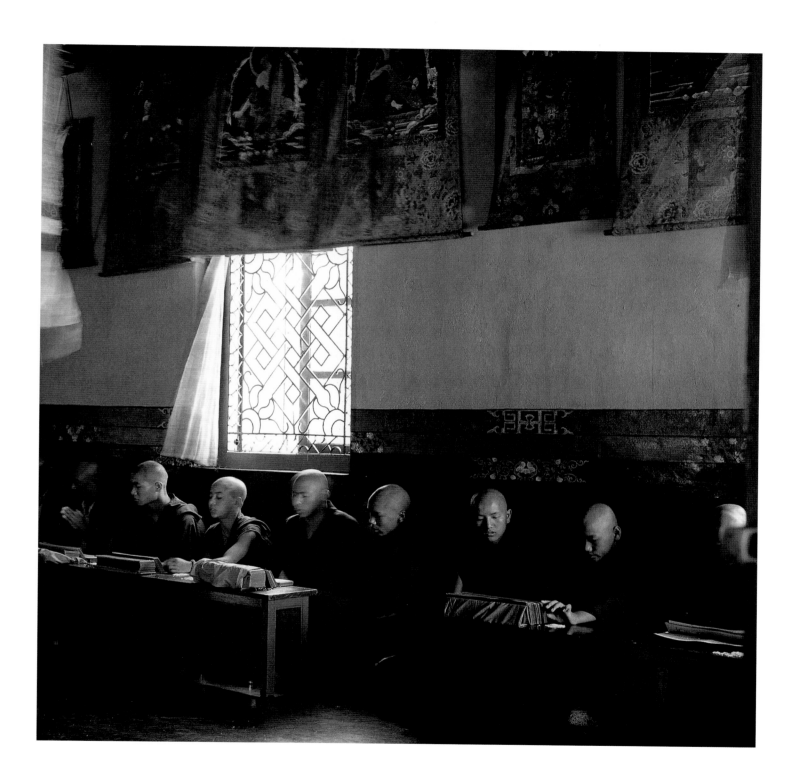

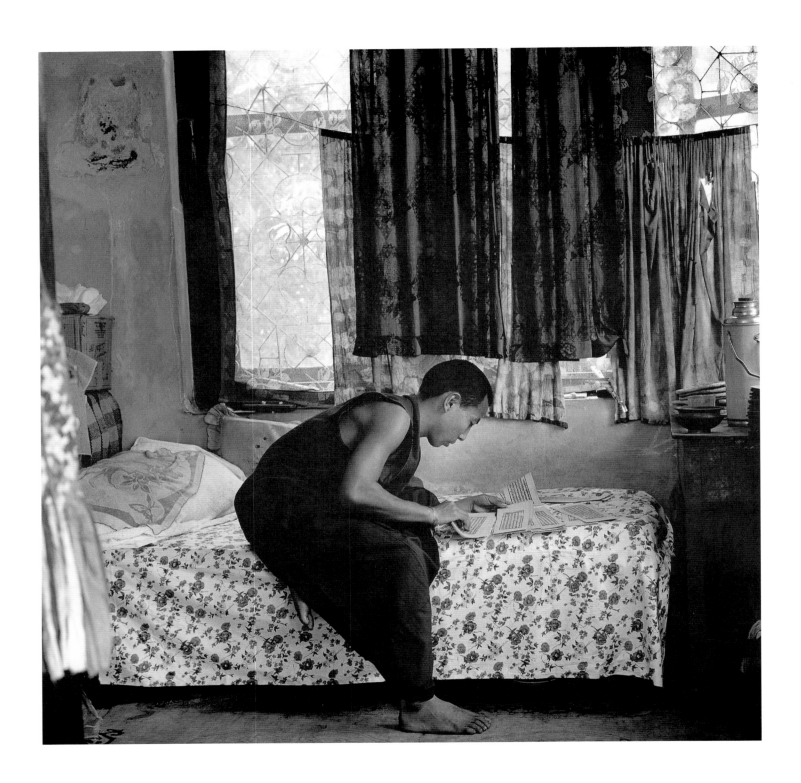

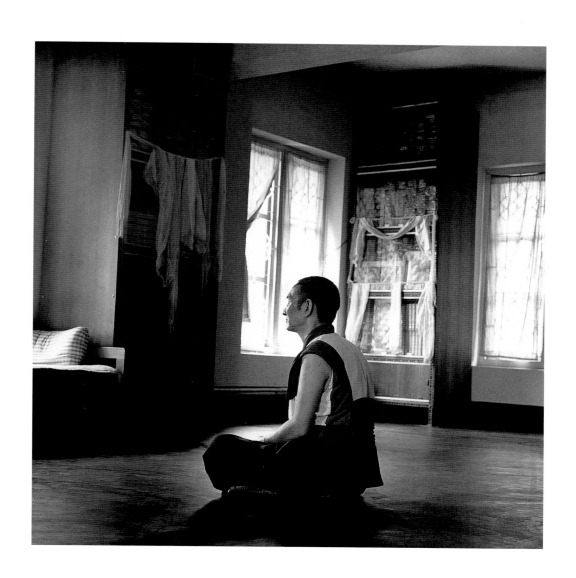

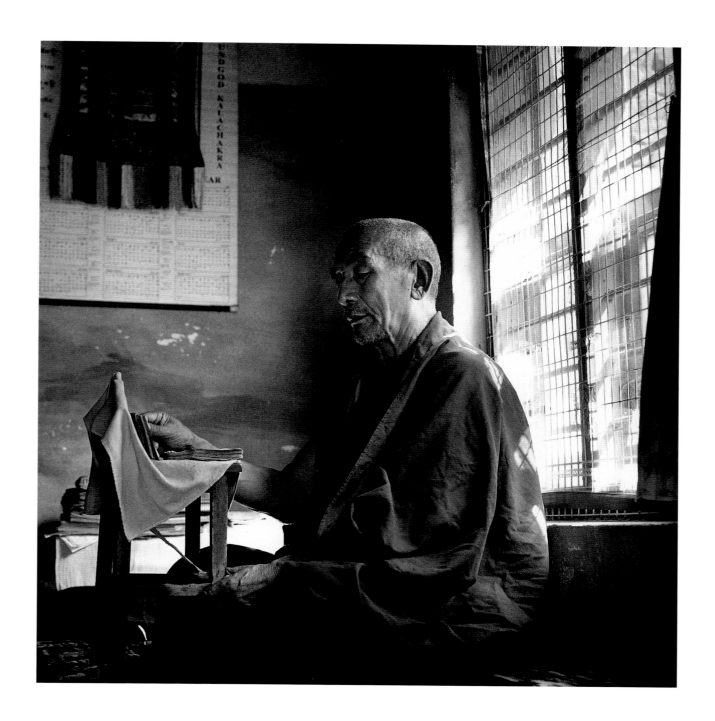

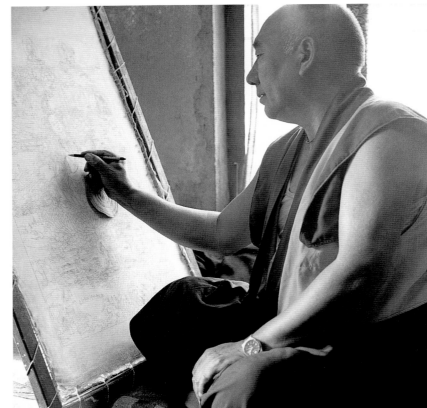

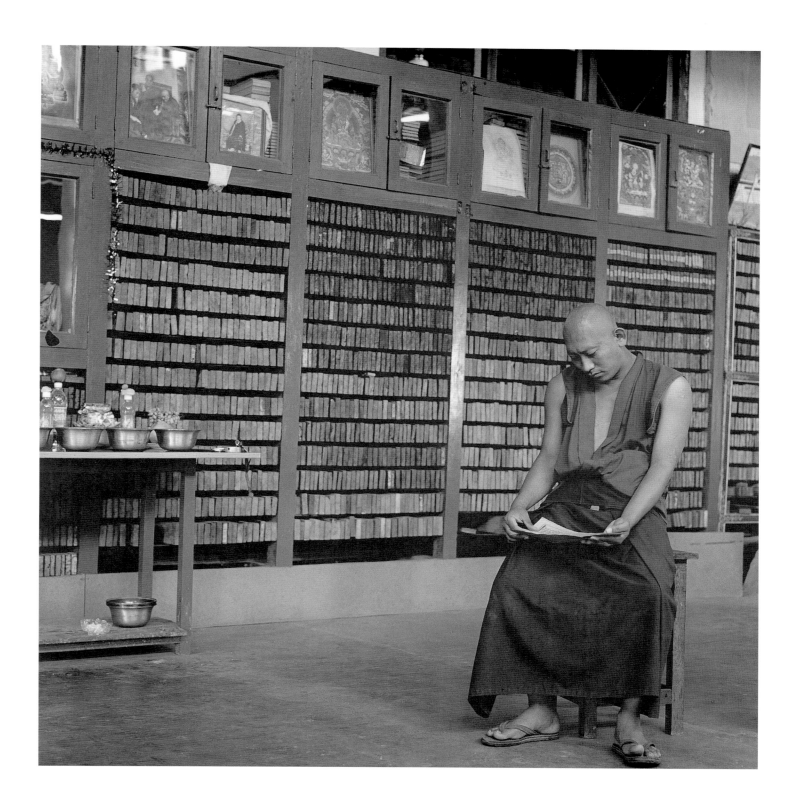

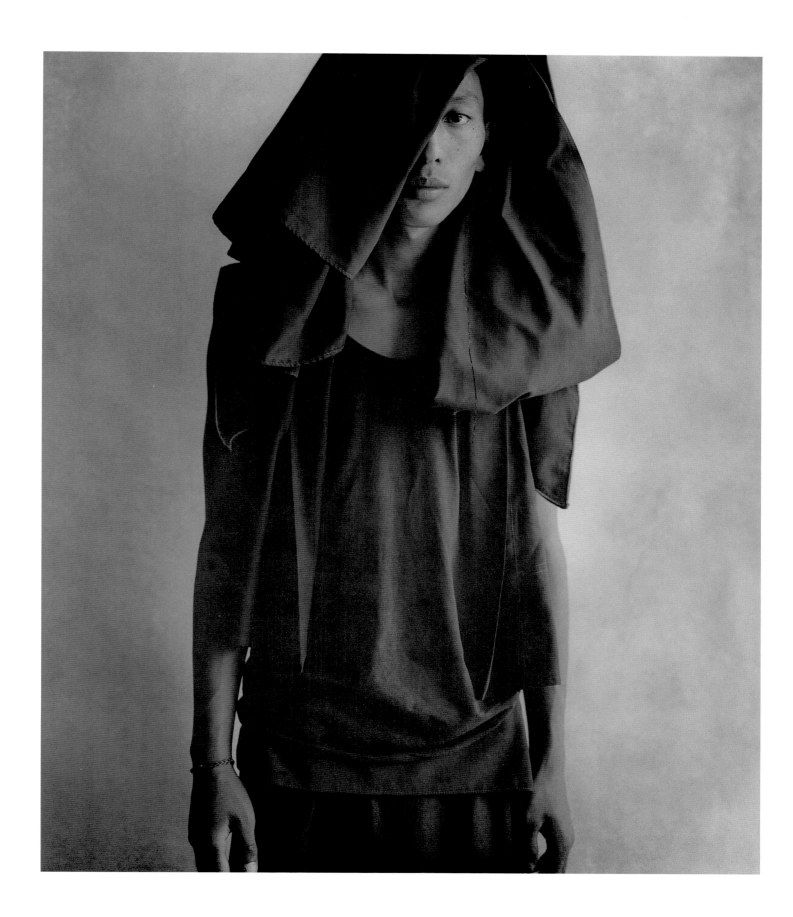

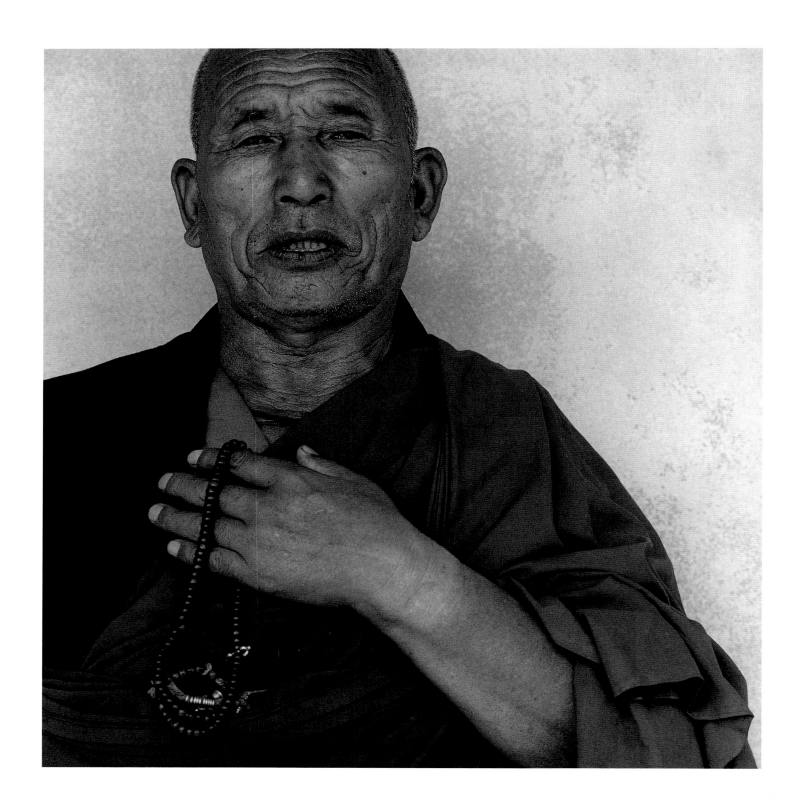

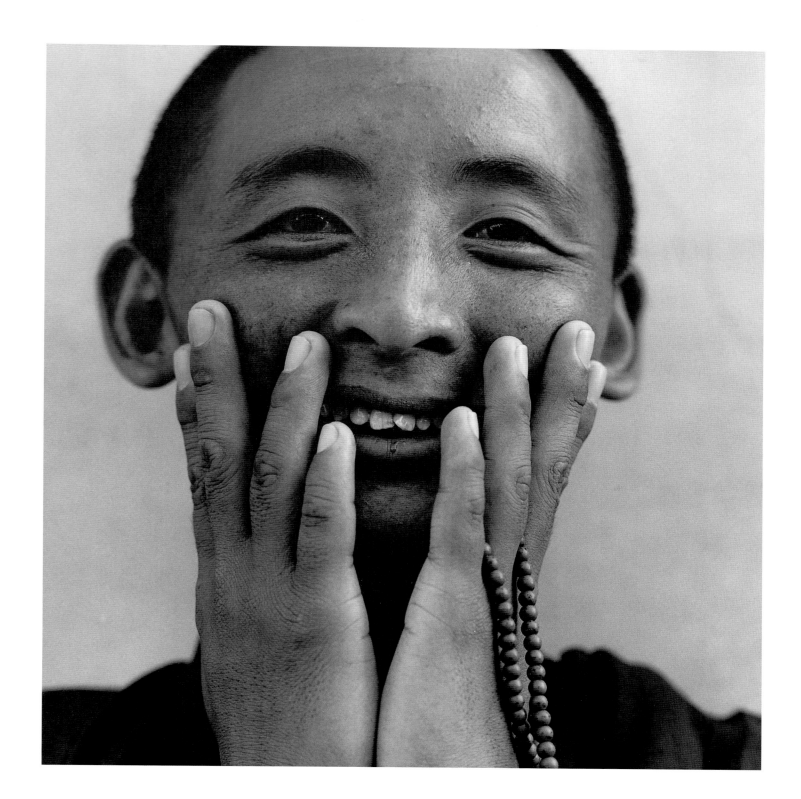

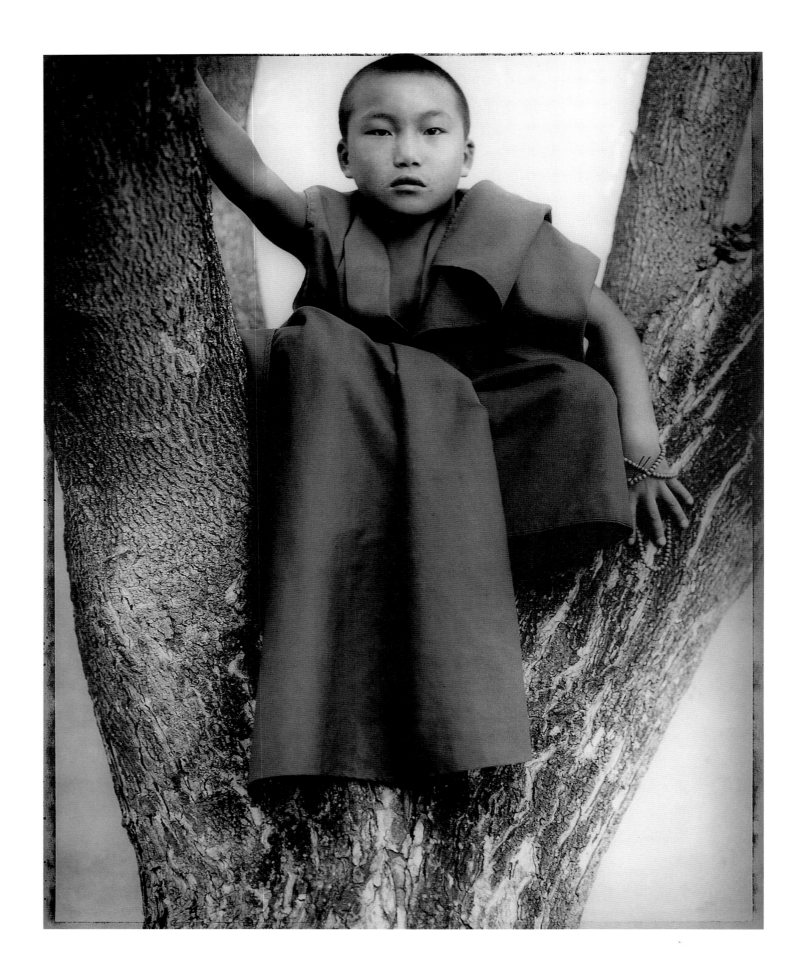

Like the dew that remains for a moment or two

On the tips of the grass and then melts with the dawn

The pleasures we find in the course of our lives

Last only an instant, they cannot endure;

While the freedom we gain when becoming a Buddha

Is a blissful attainment not subject to change.

Aim every effort to this wondrous achievement—

The Sons of the Buddha all practice this way.

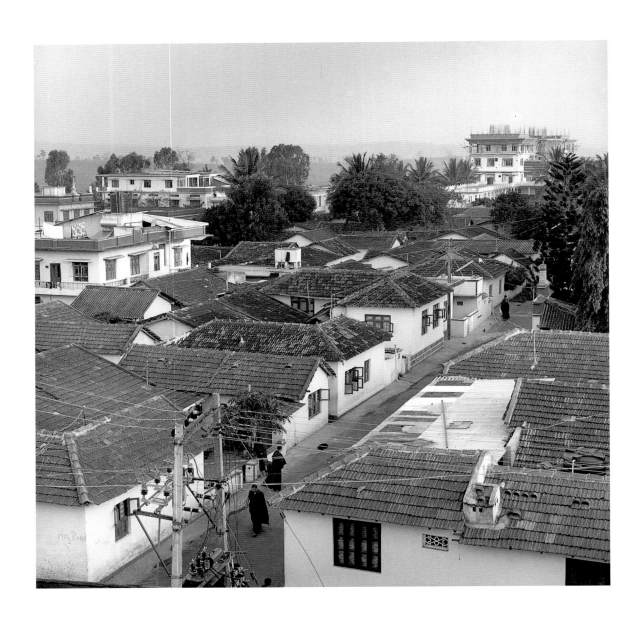

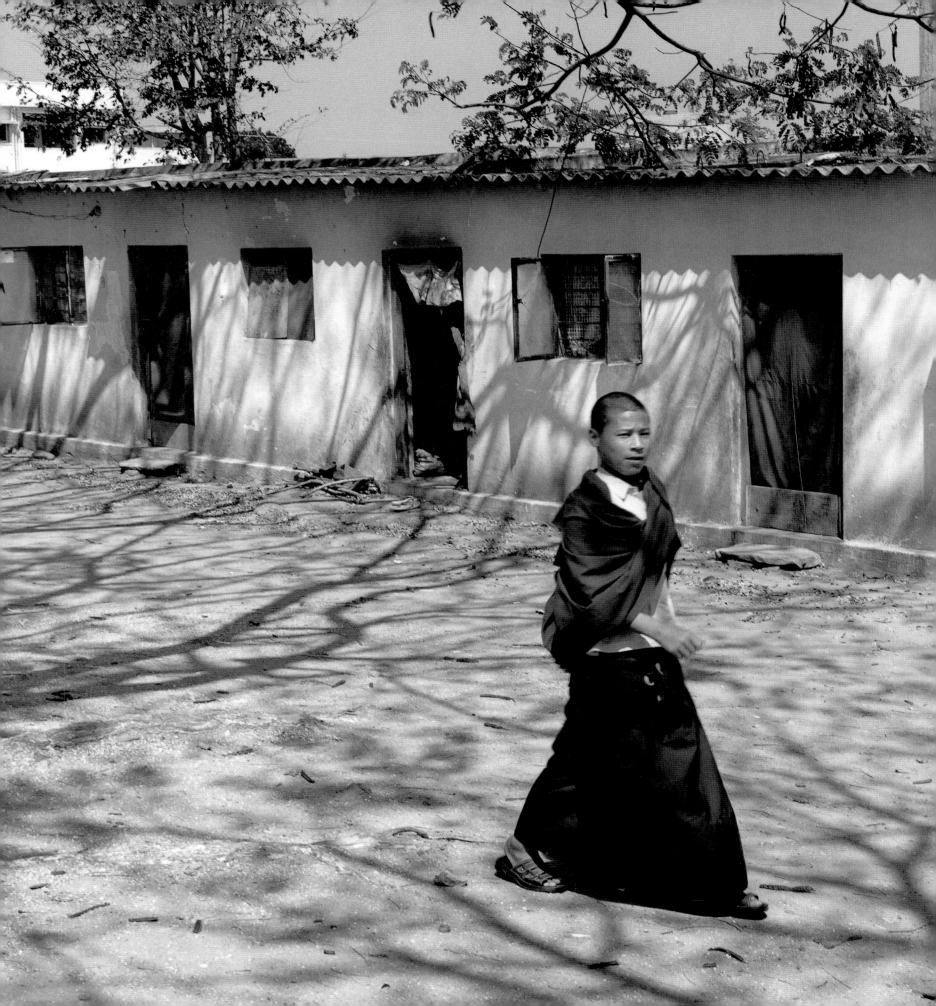

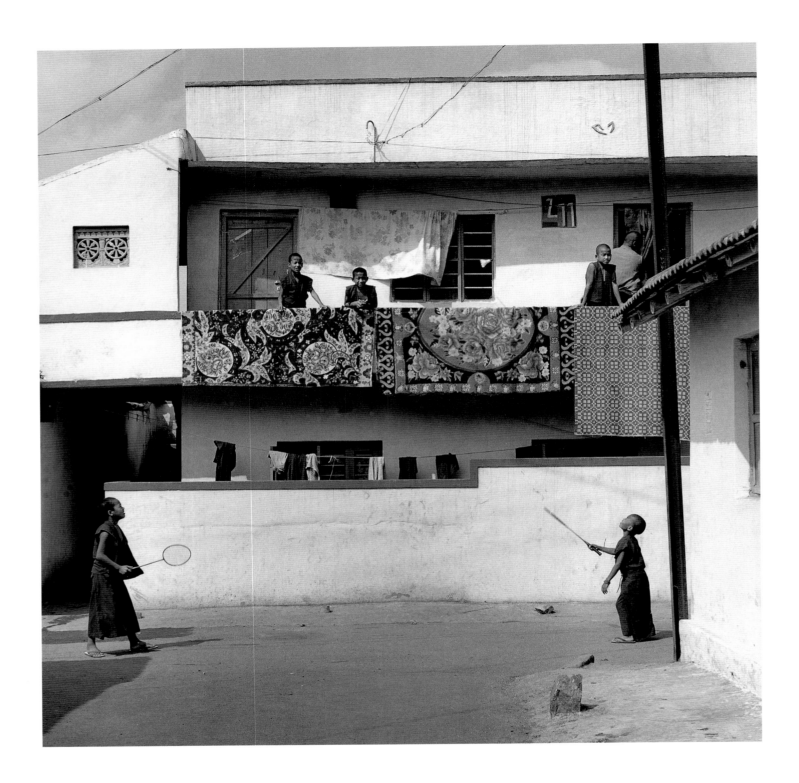

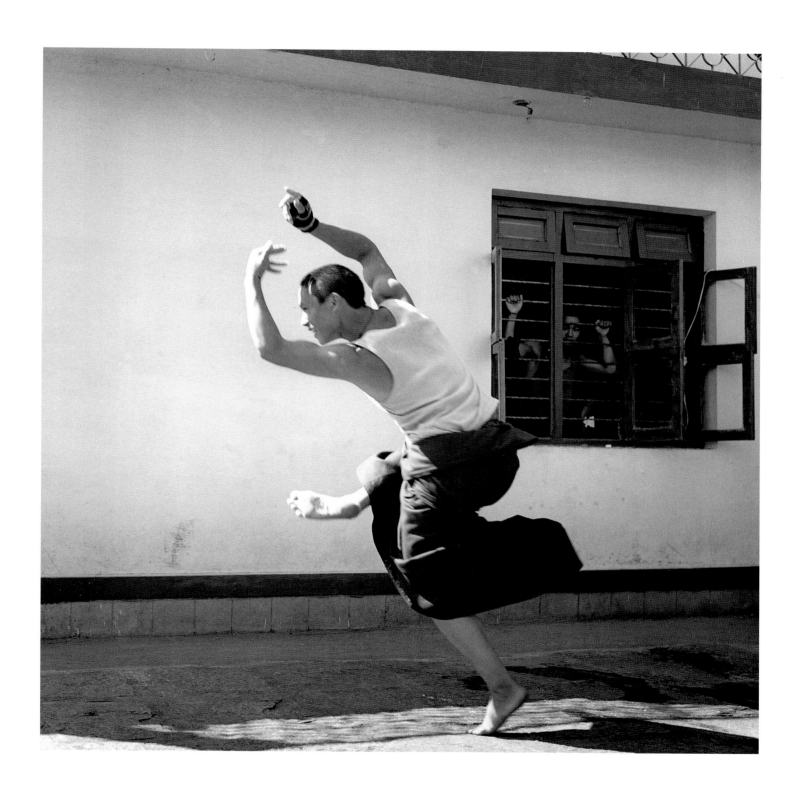

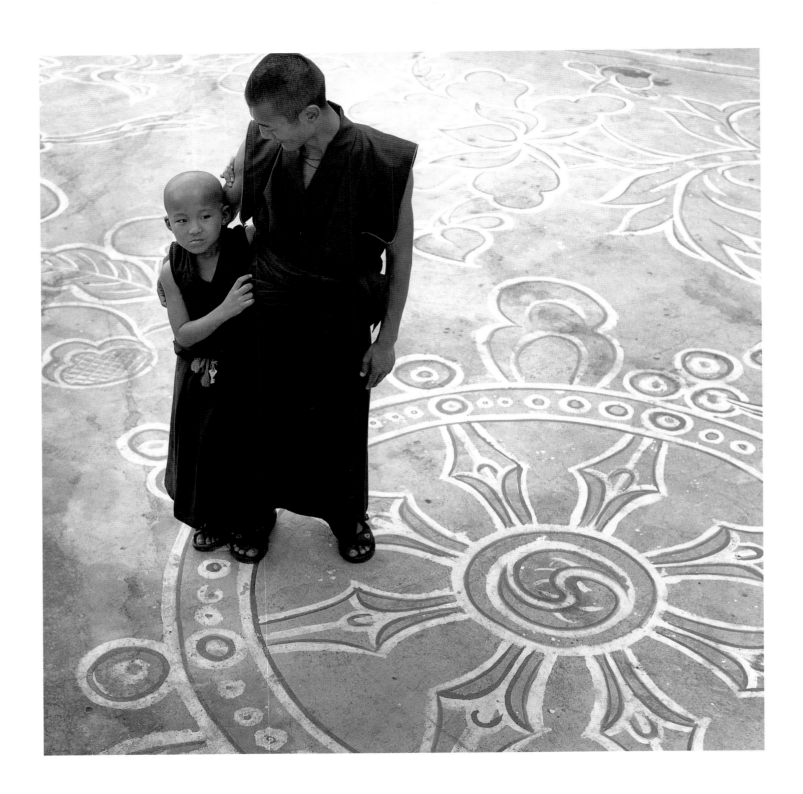

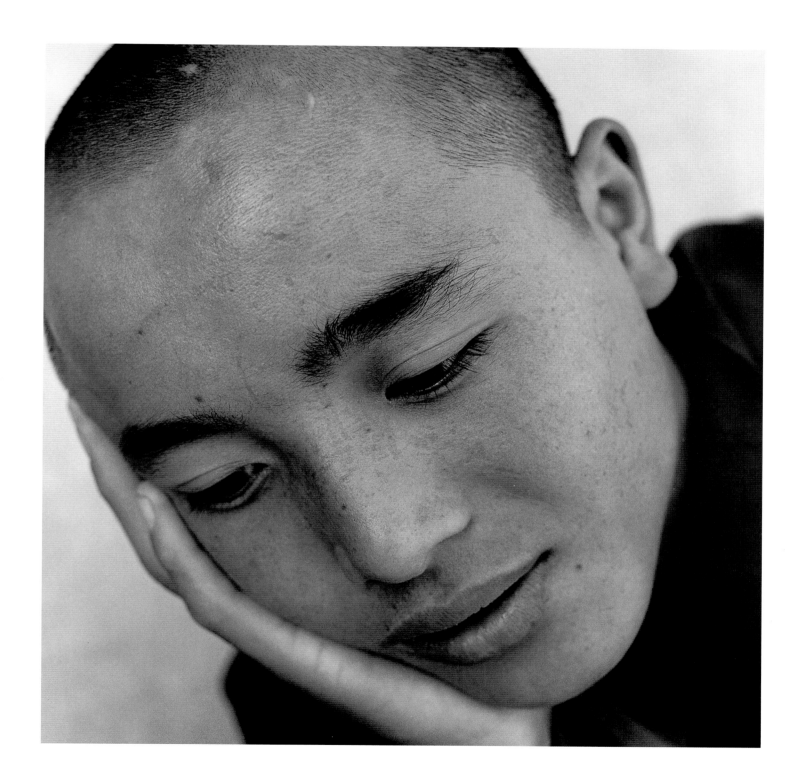

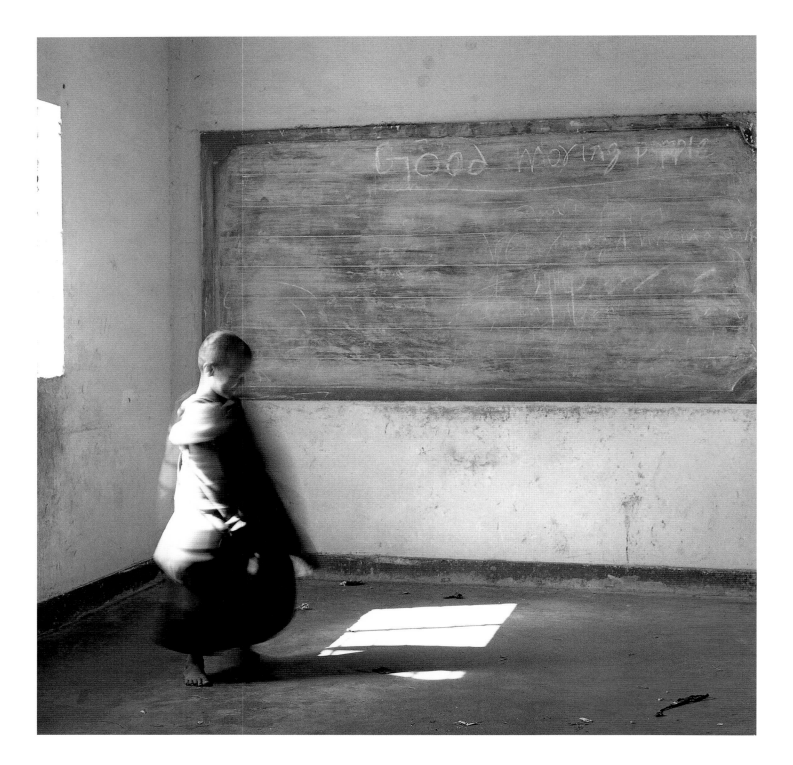

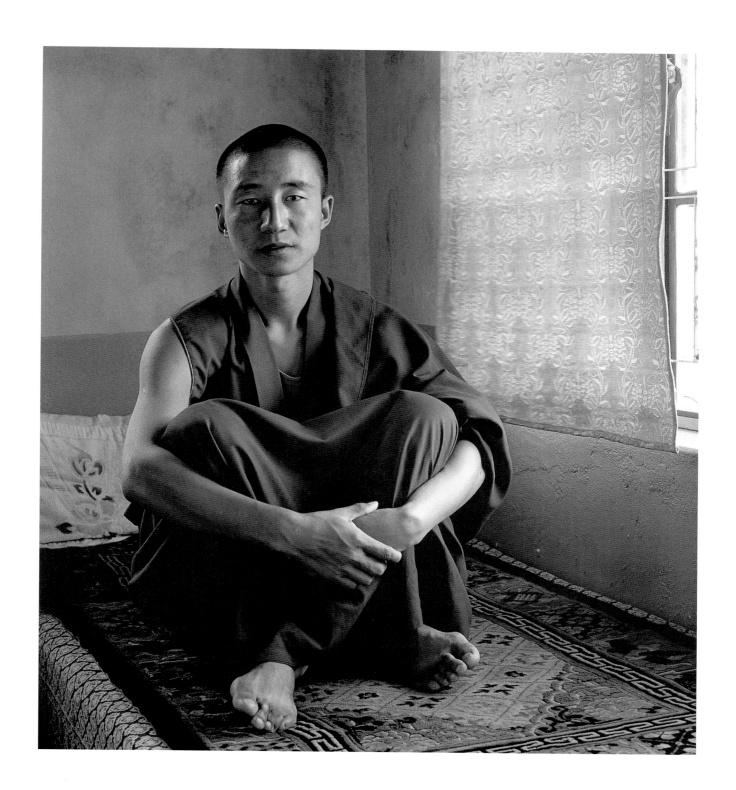

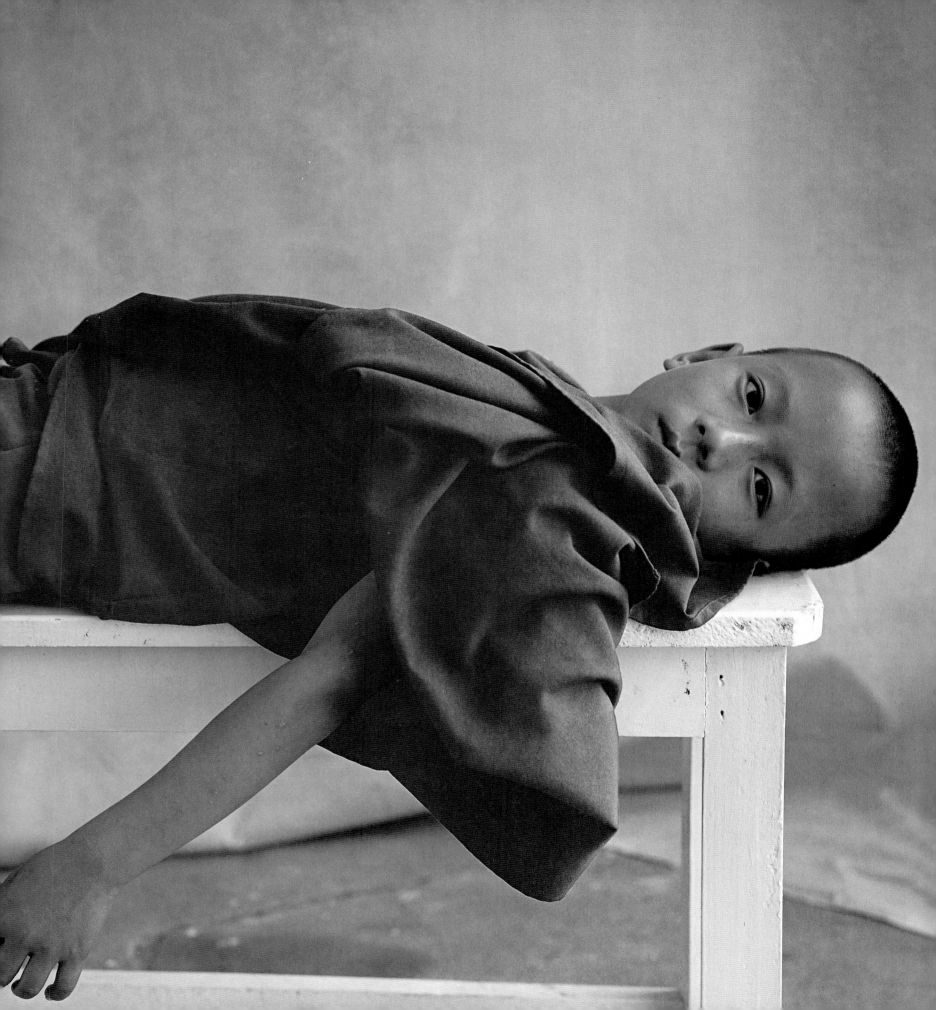

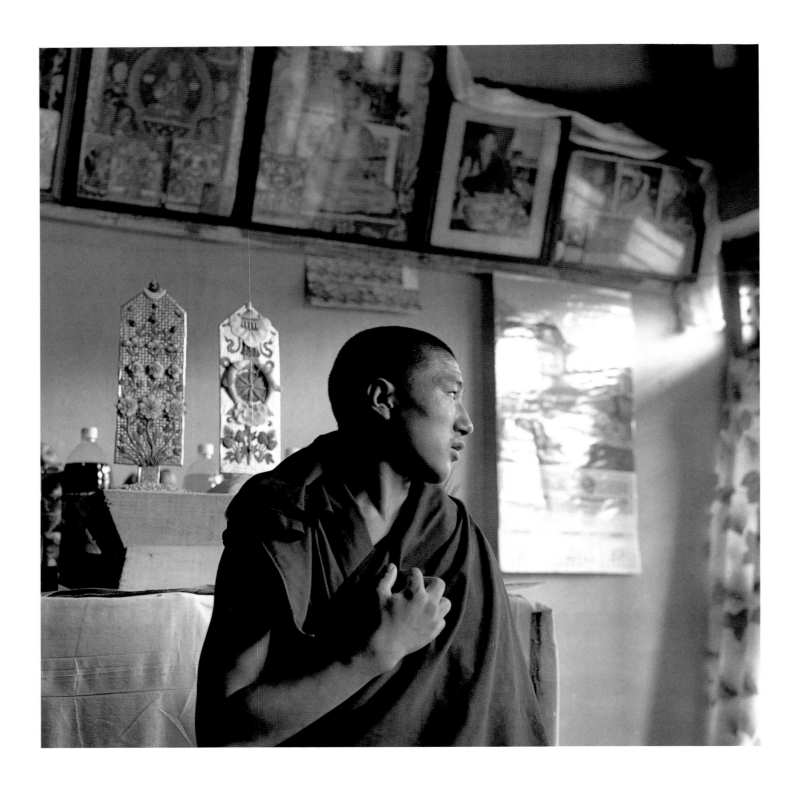

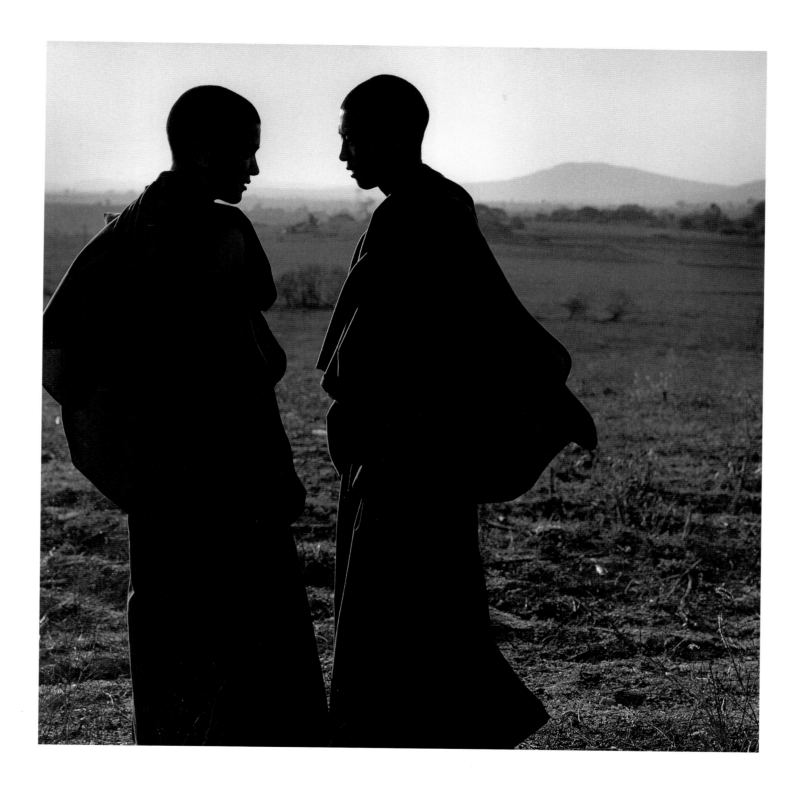

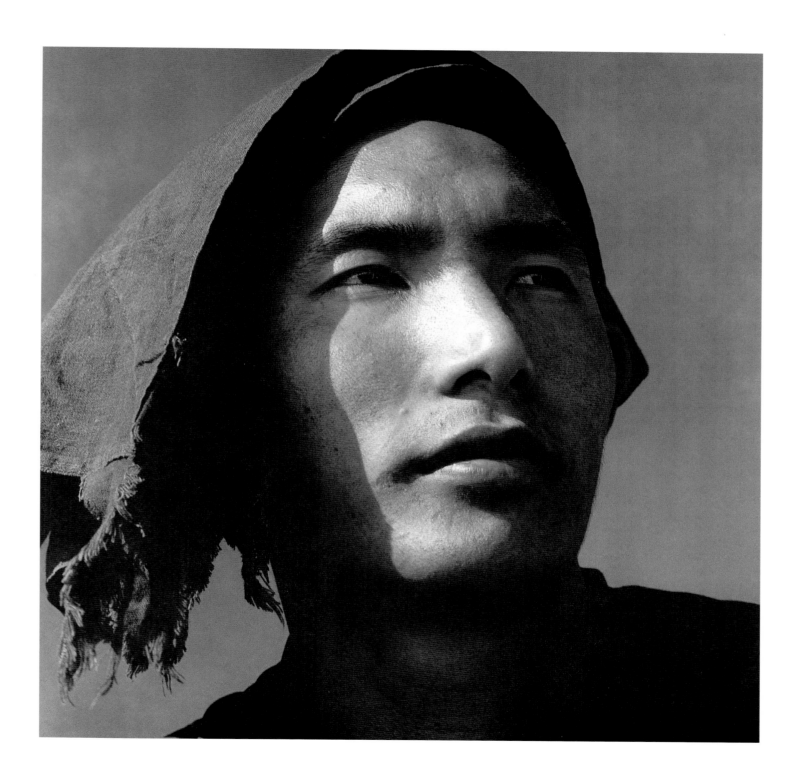

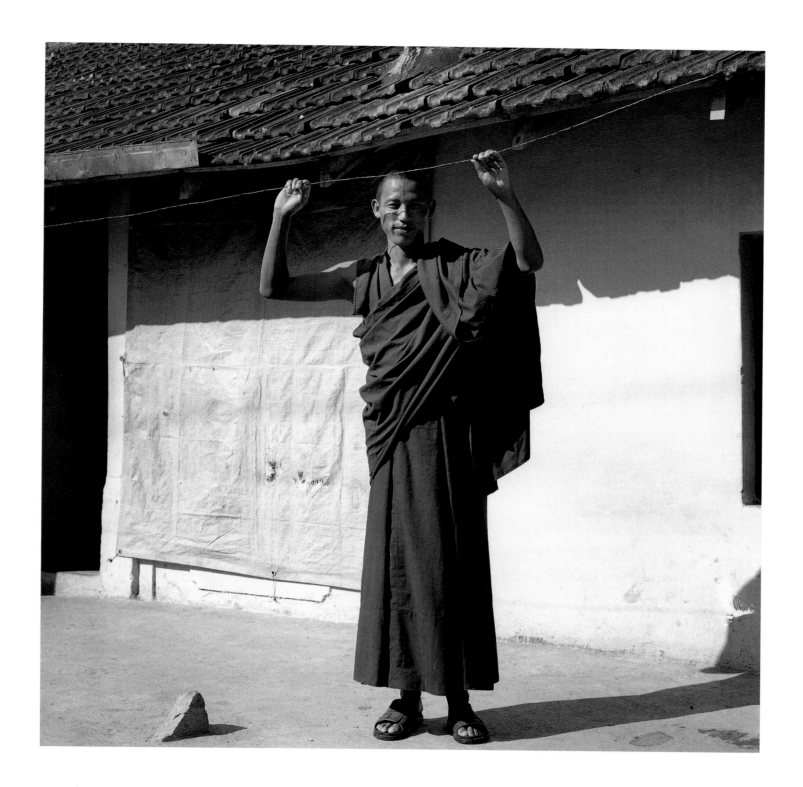

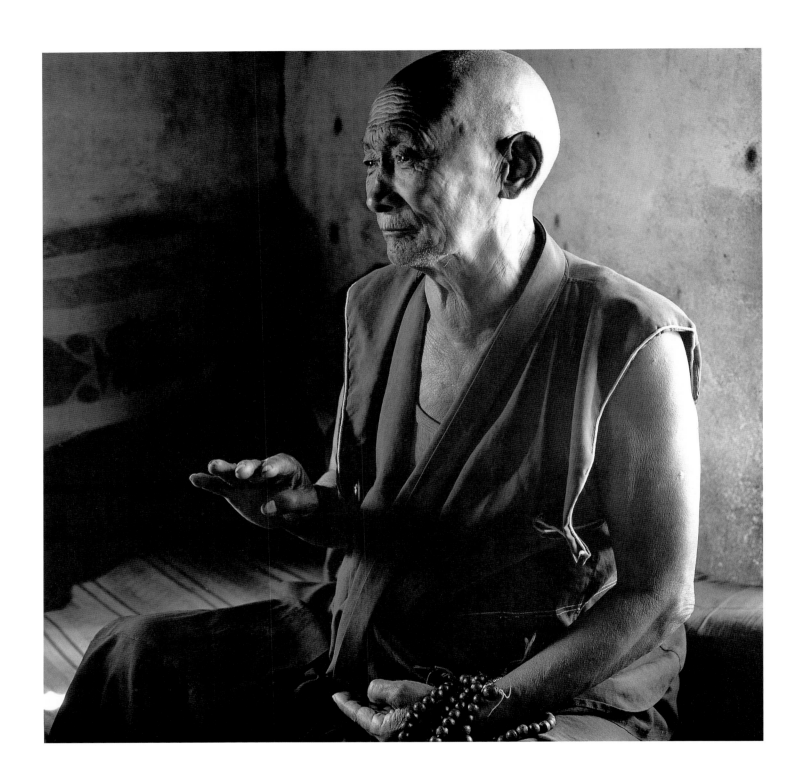

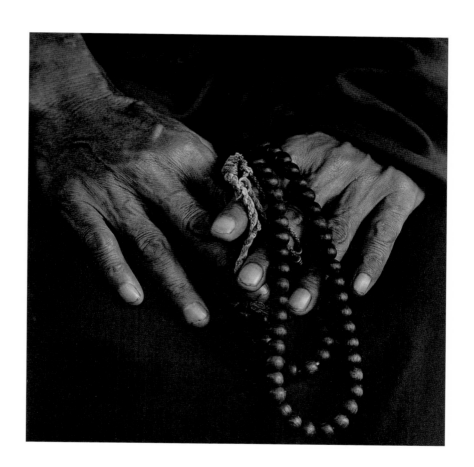

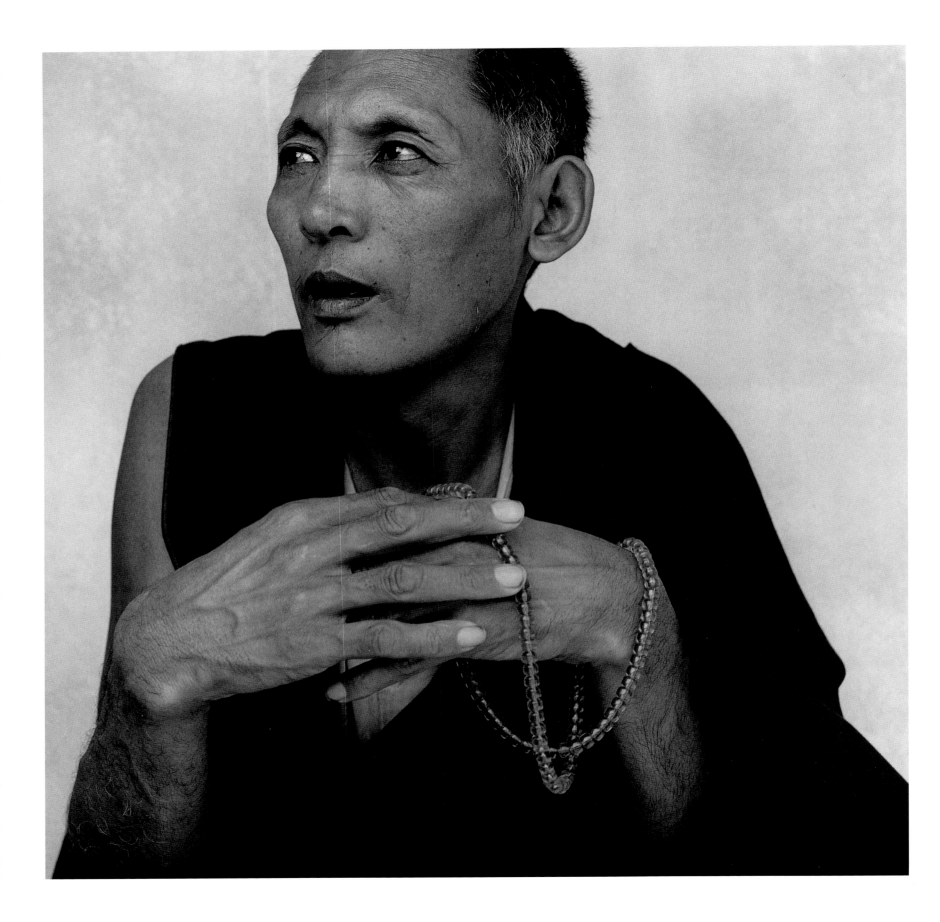

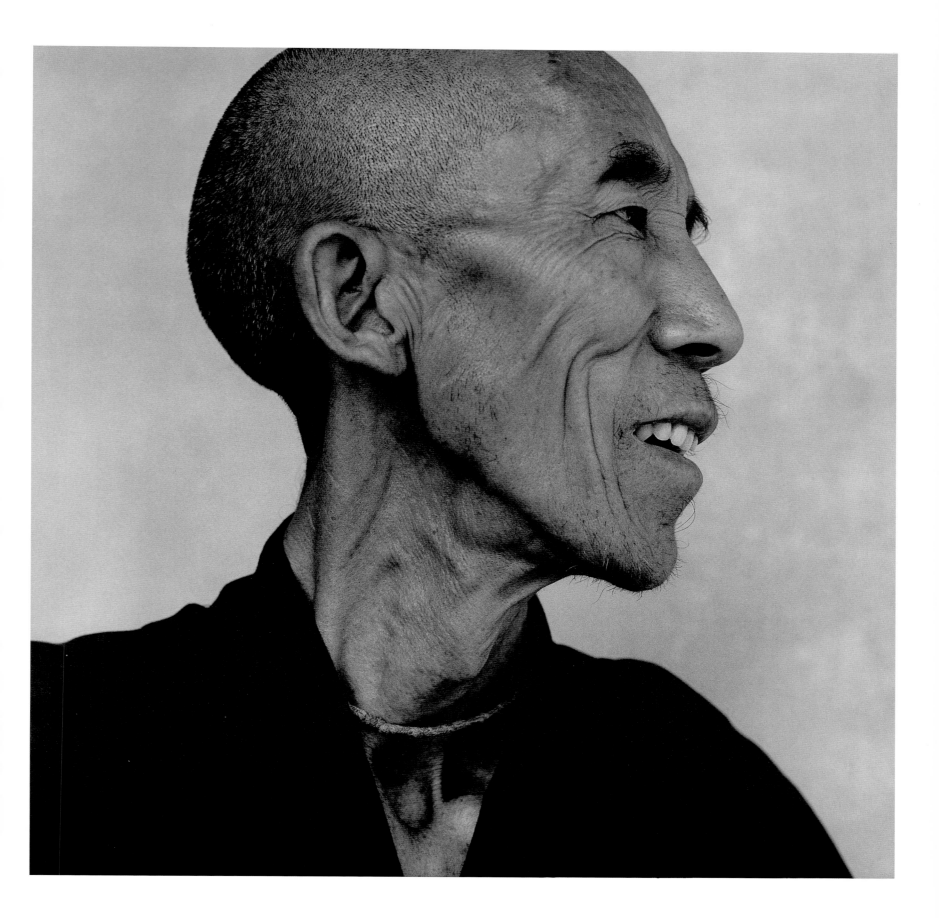

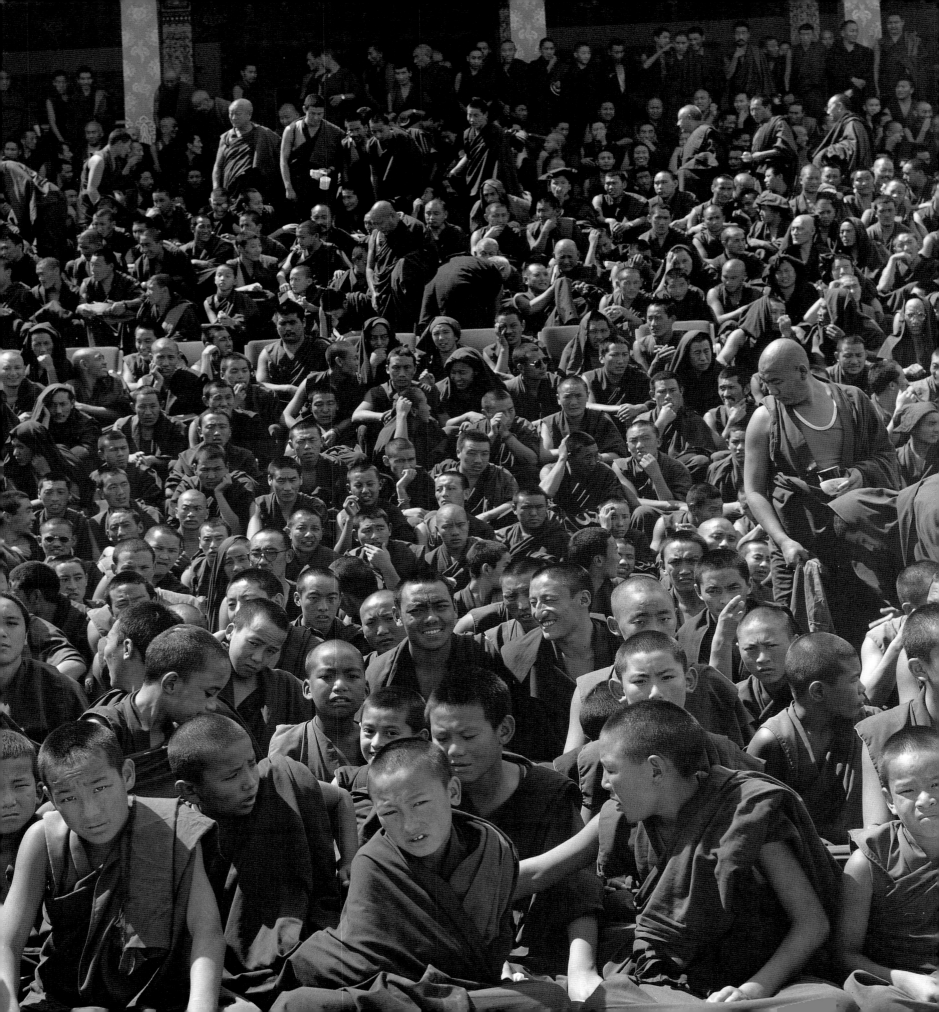

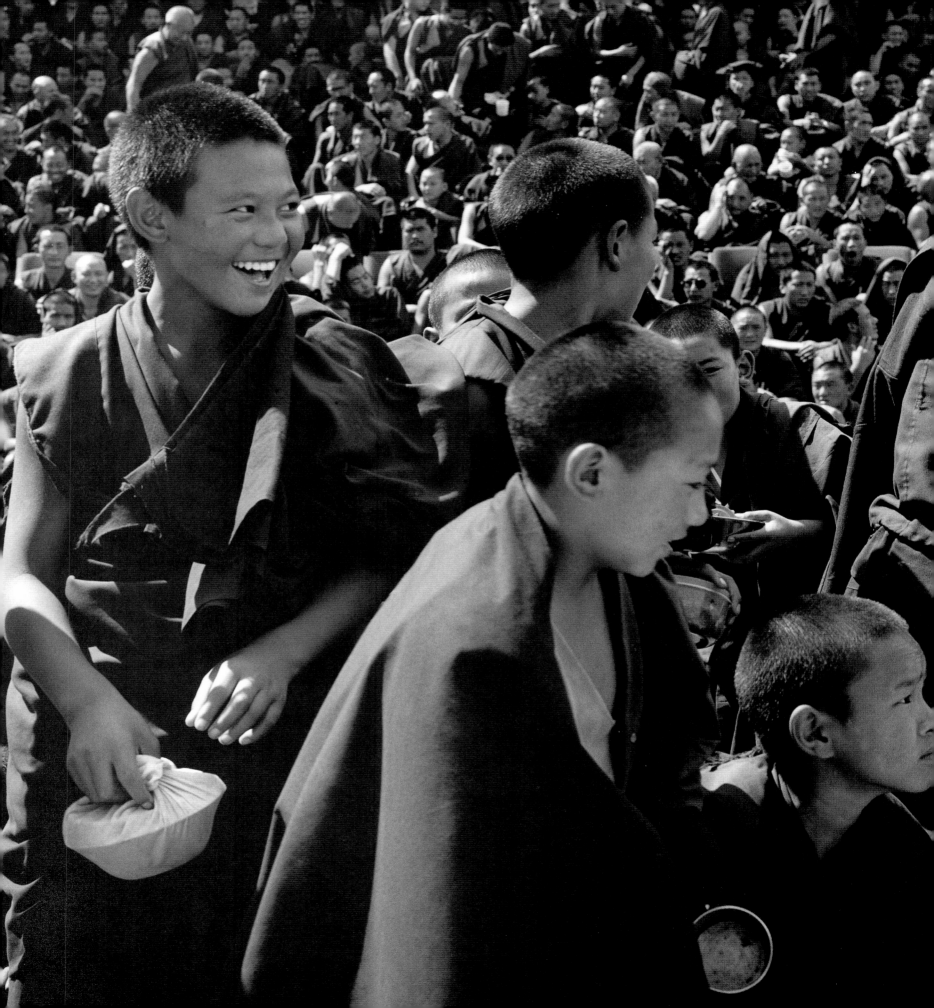

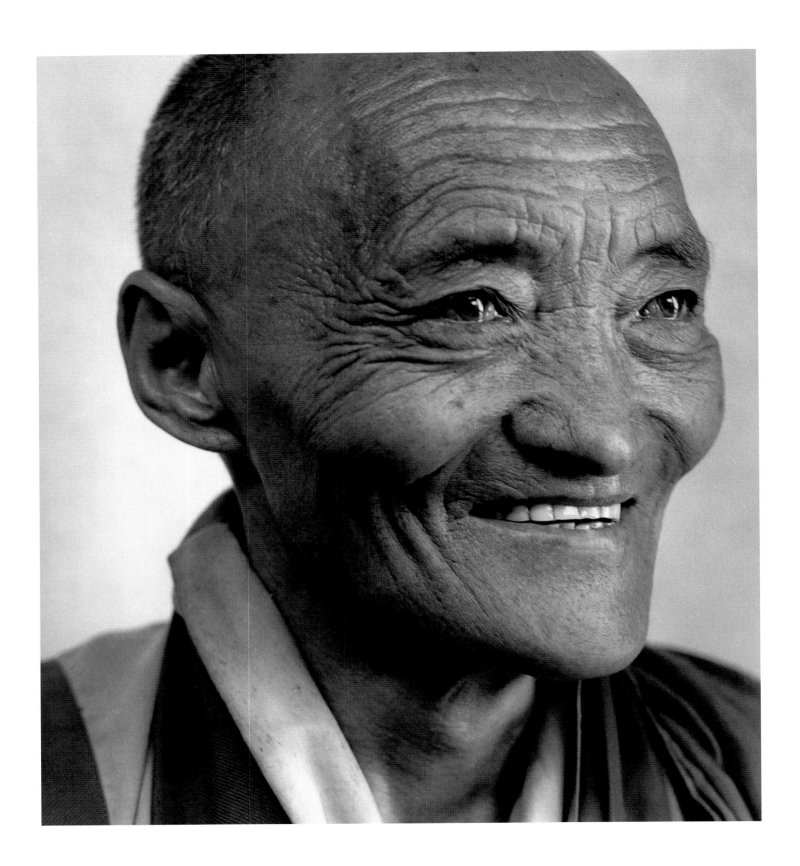

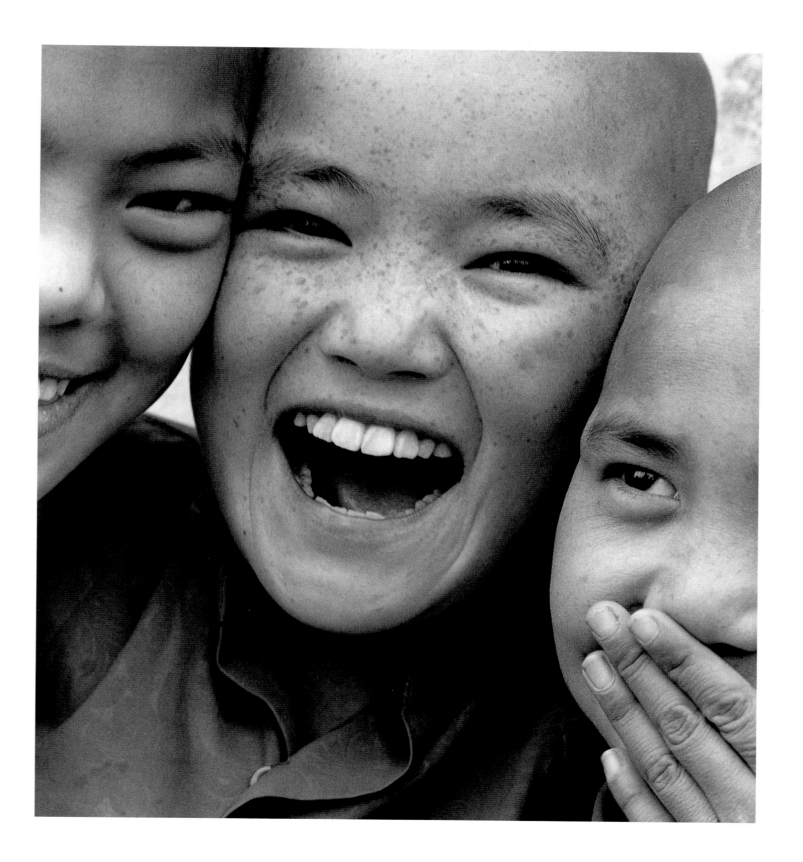

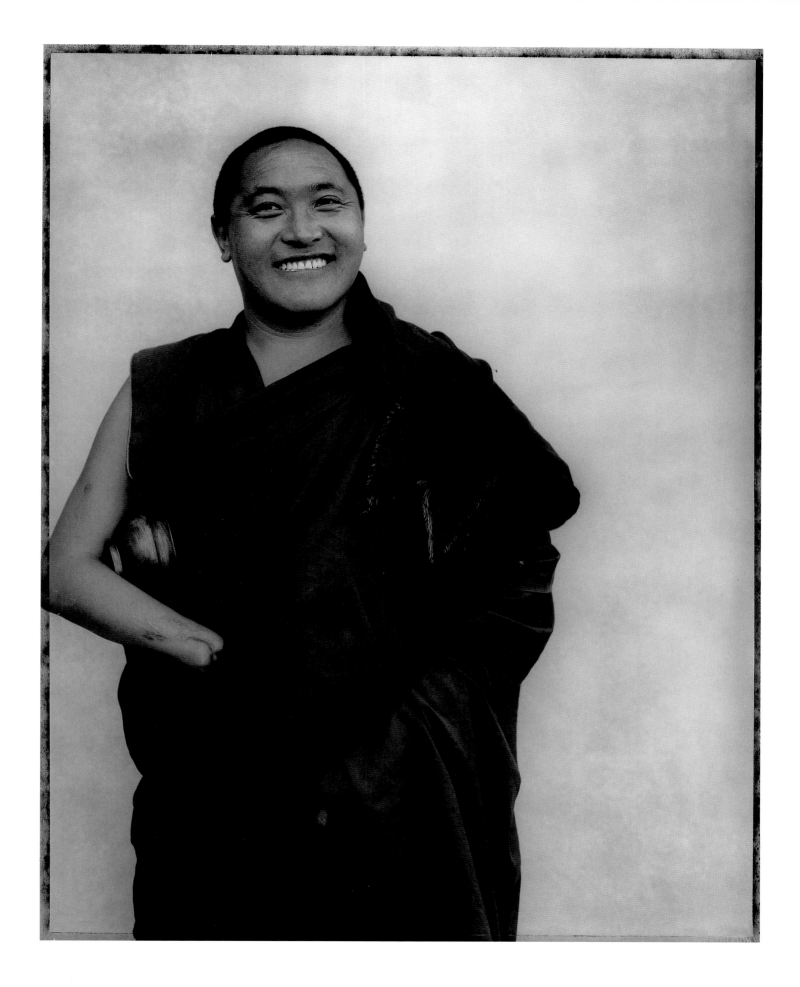

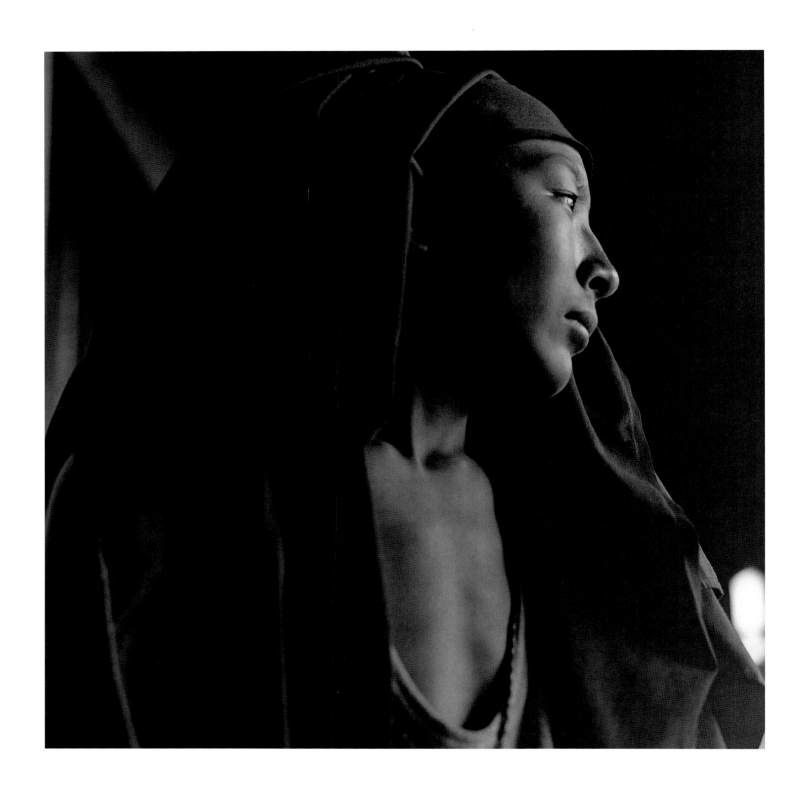

Whatever appears to be truly existent
Is merely what mind in delusion creates;
This mind of ours also is from the beginning
Devoid of an essence inherently real.
Then realizing Truth is beyond the conceptions
We have of the known and the knower as well,
Dispel the belief in inherent existence—
The Sons of the Buddha all practice this way.

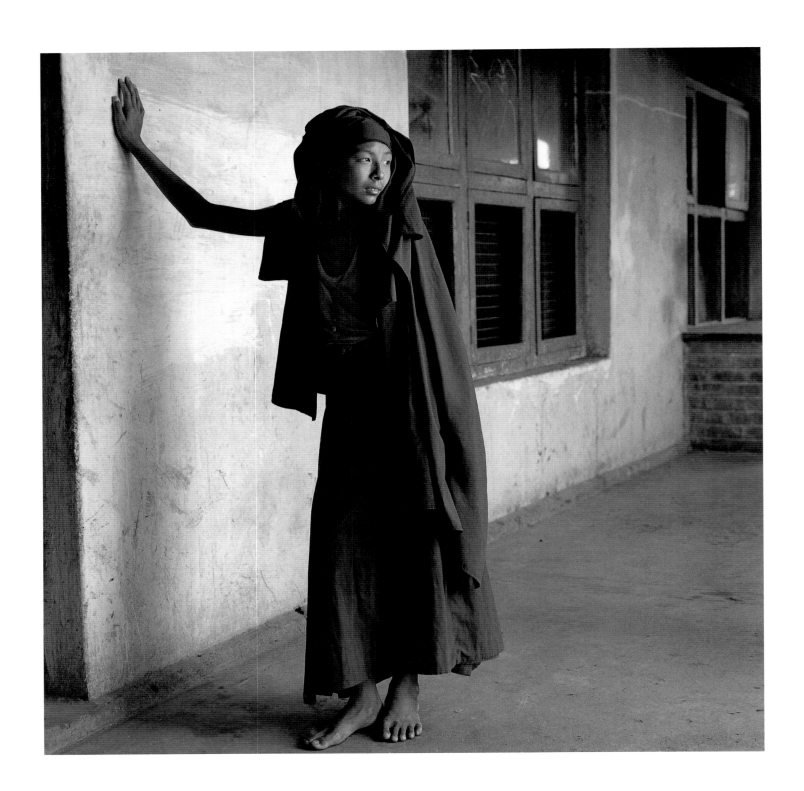

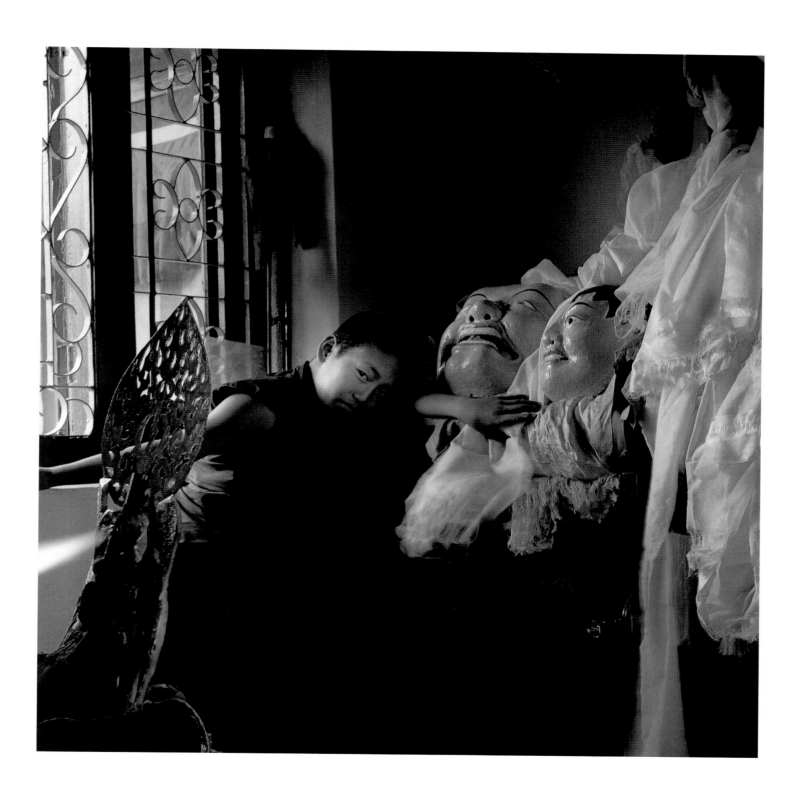

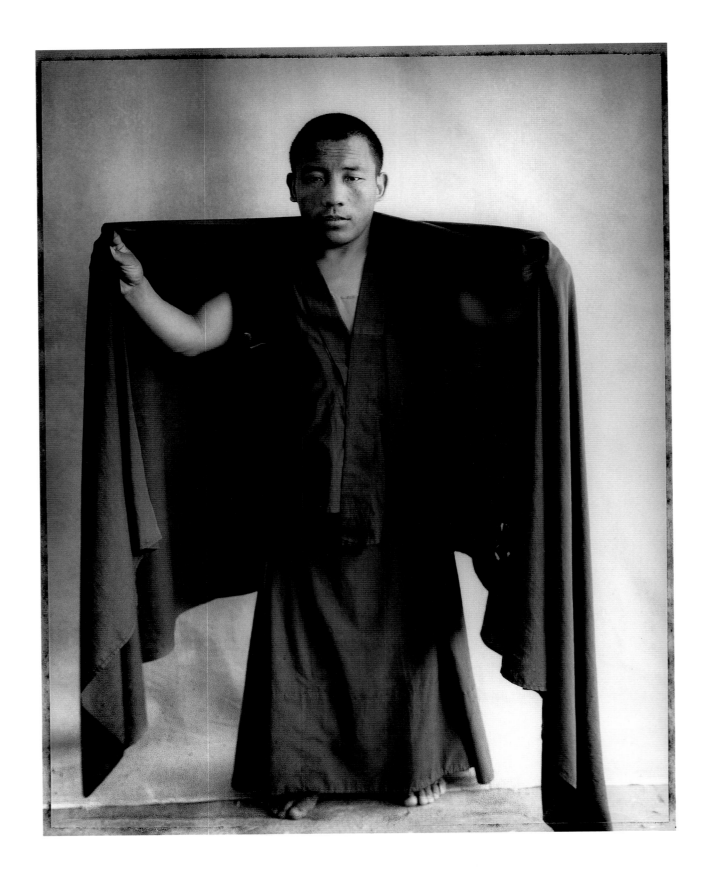

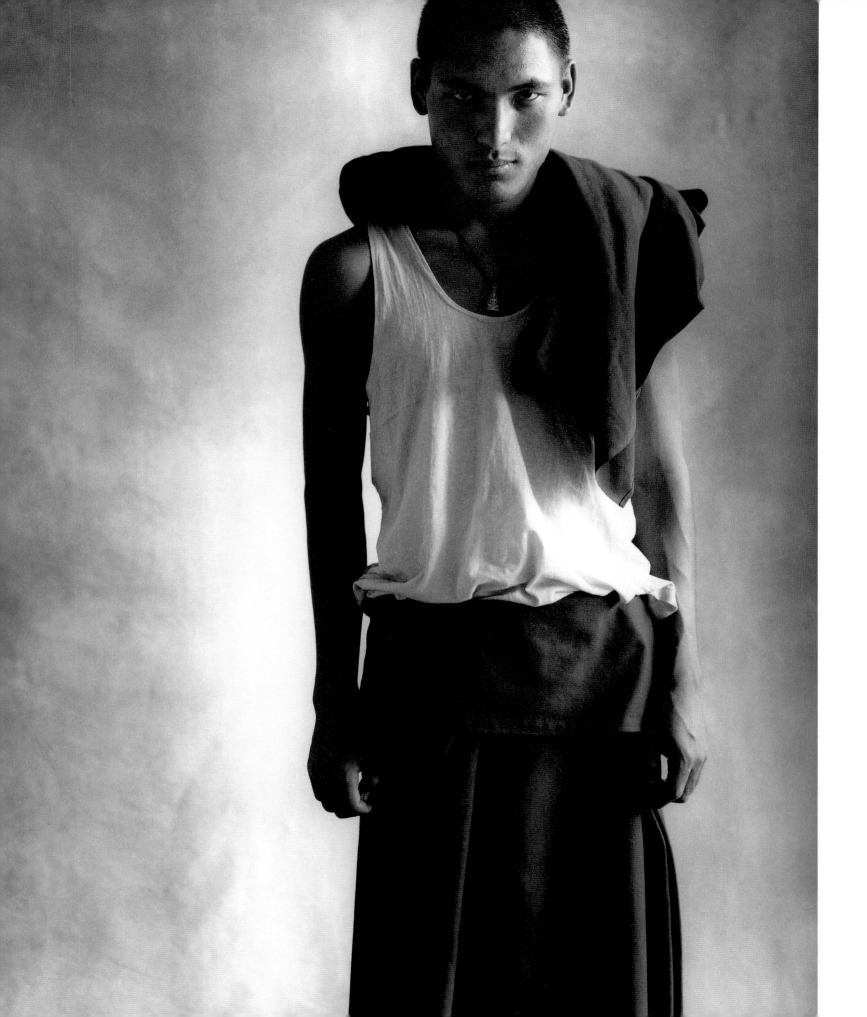

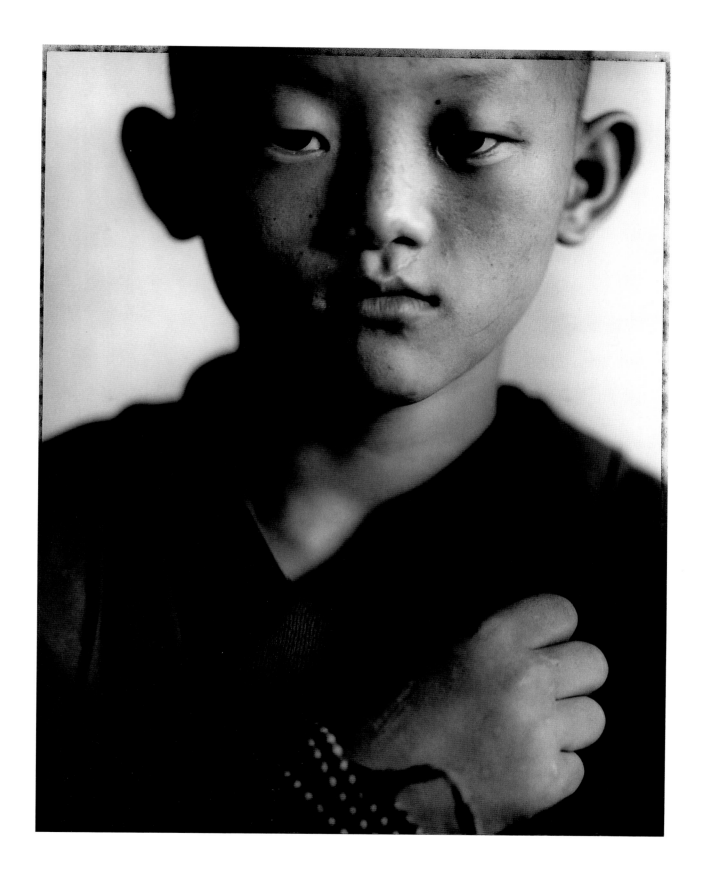

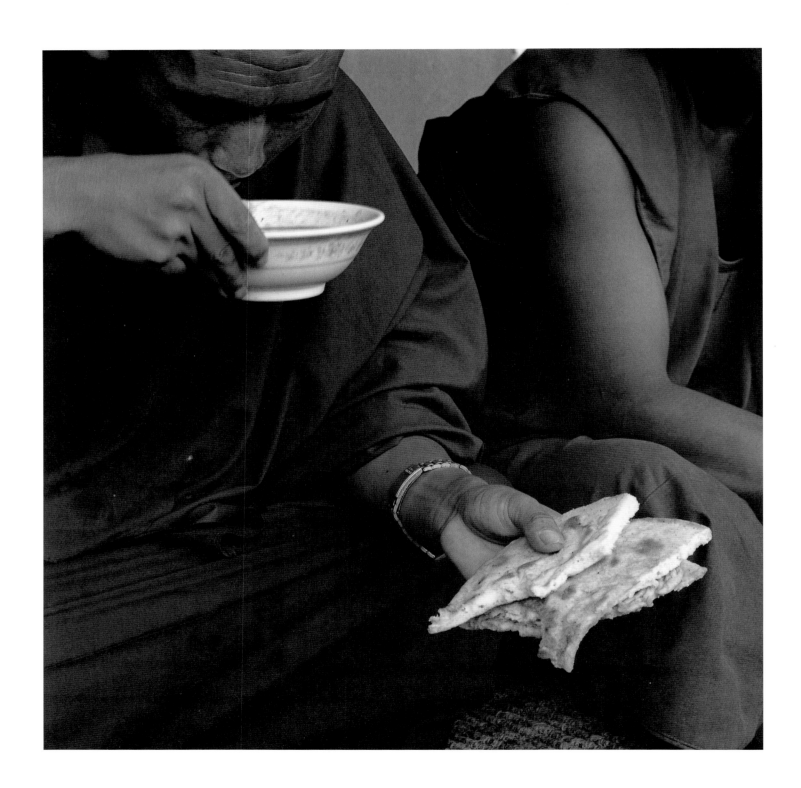

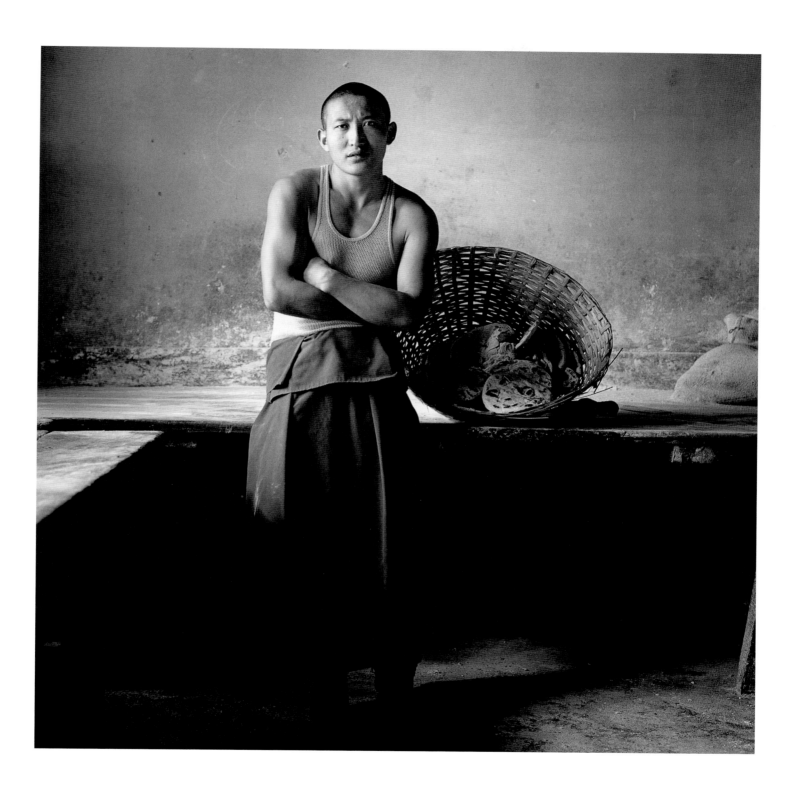

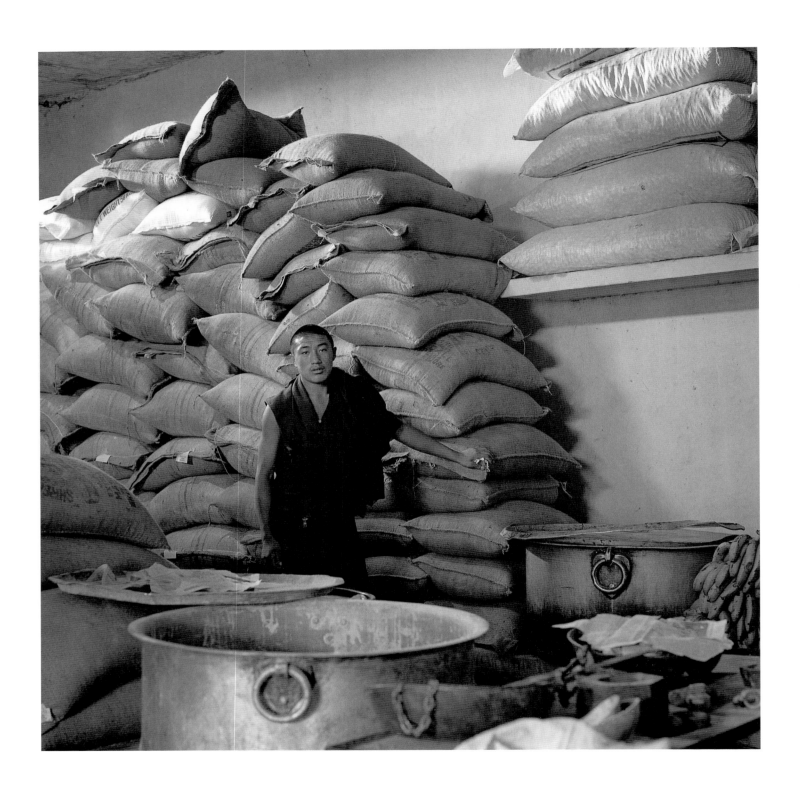

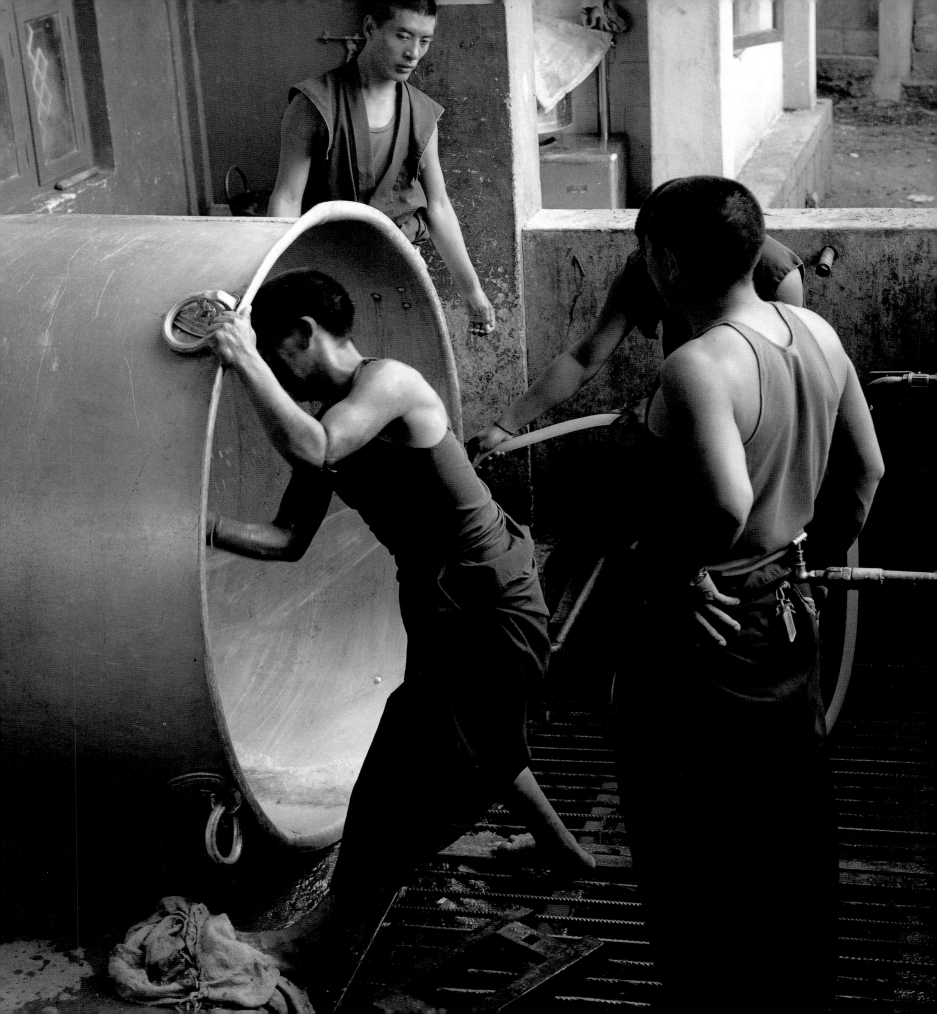

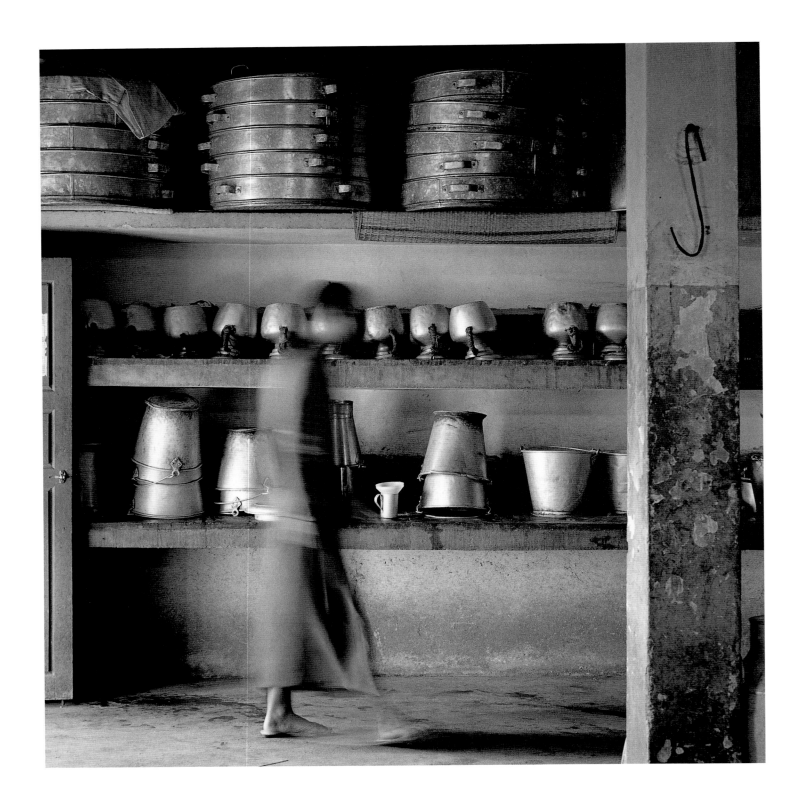

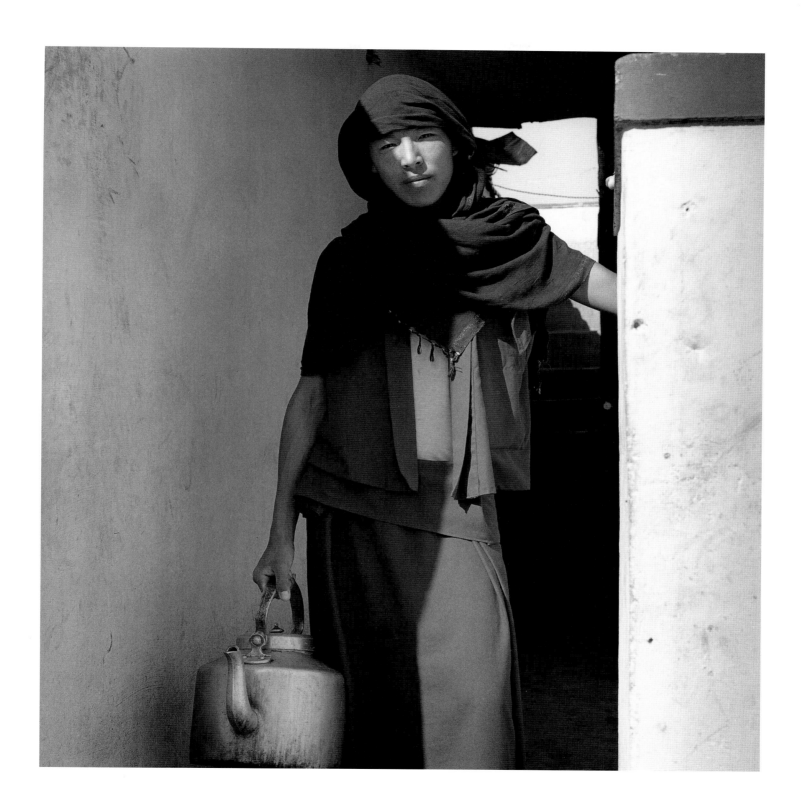

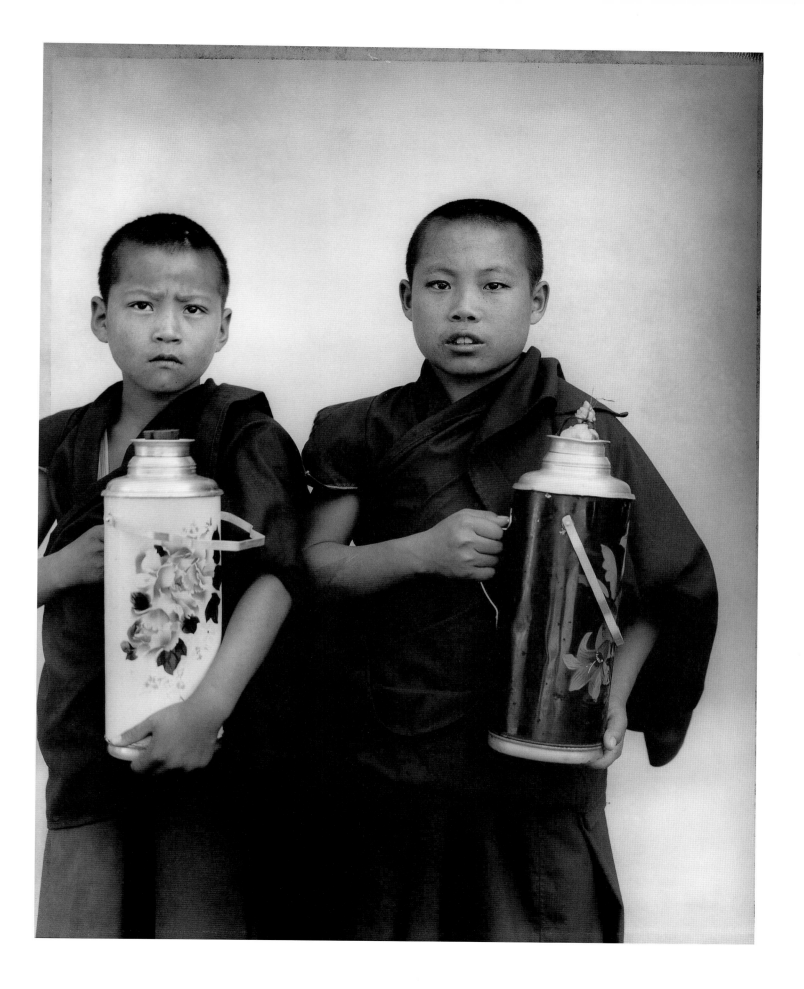

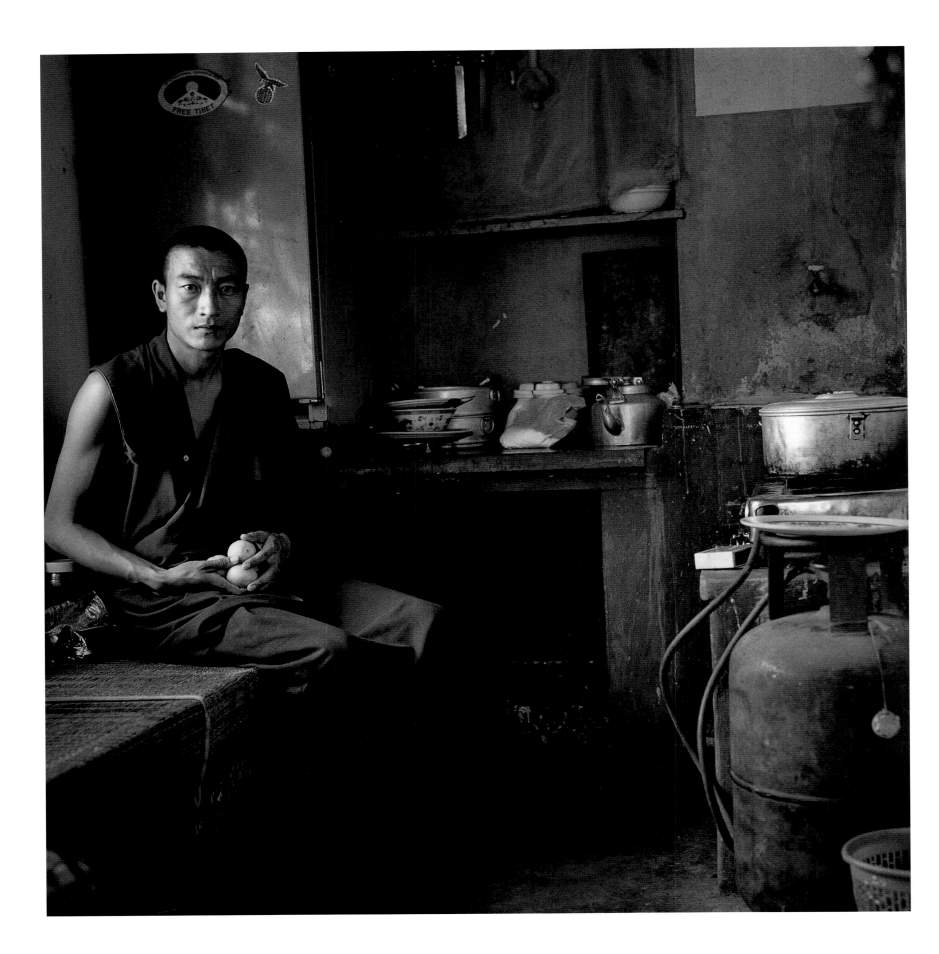

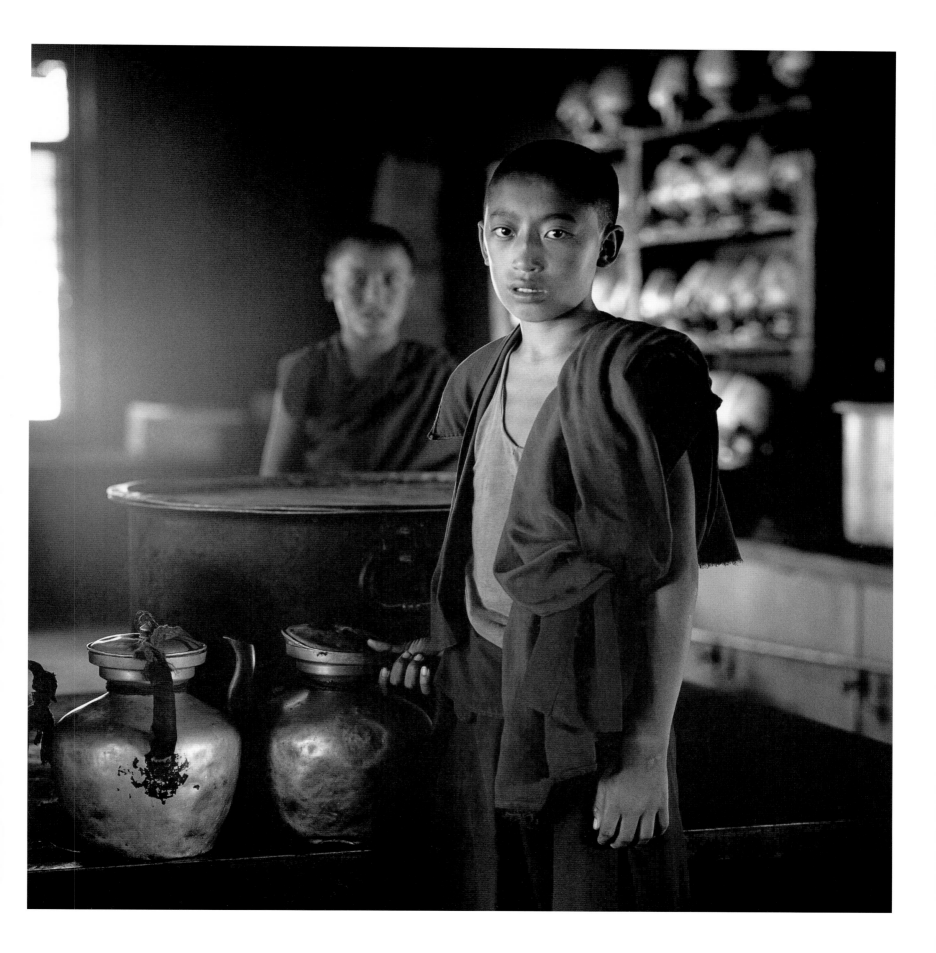

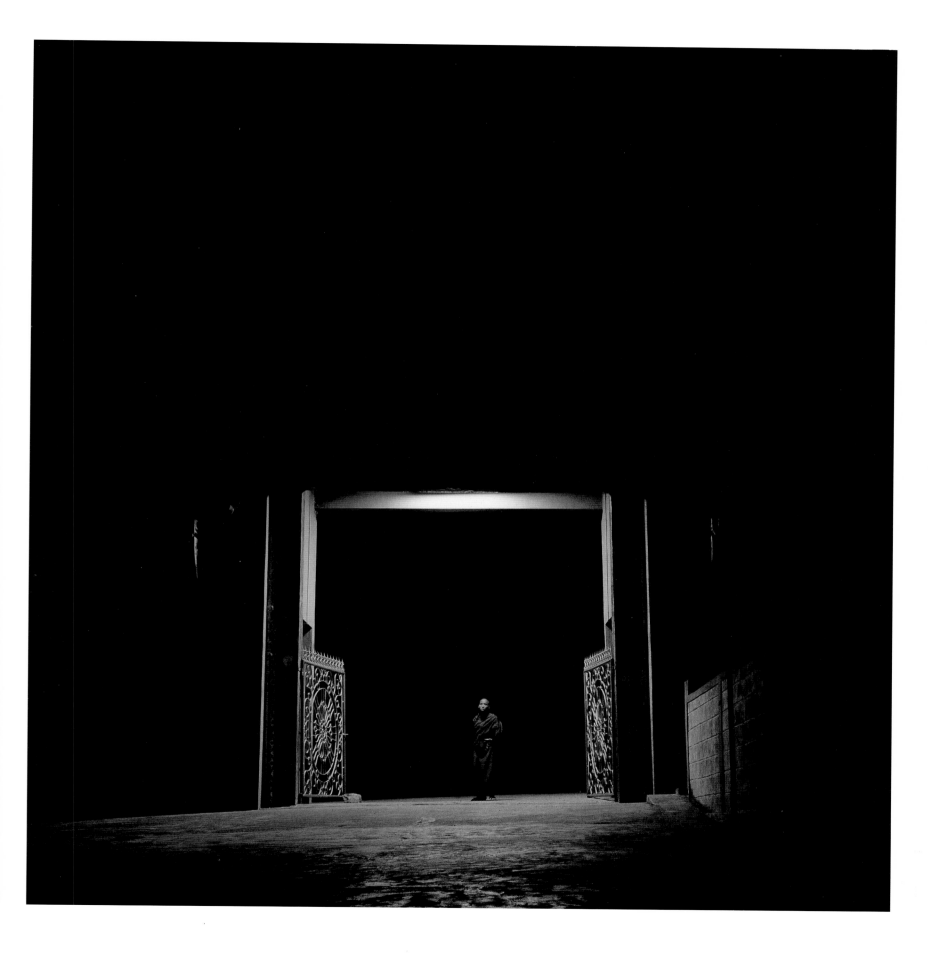

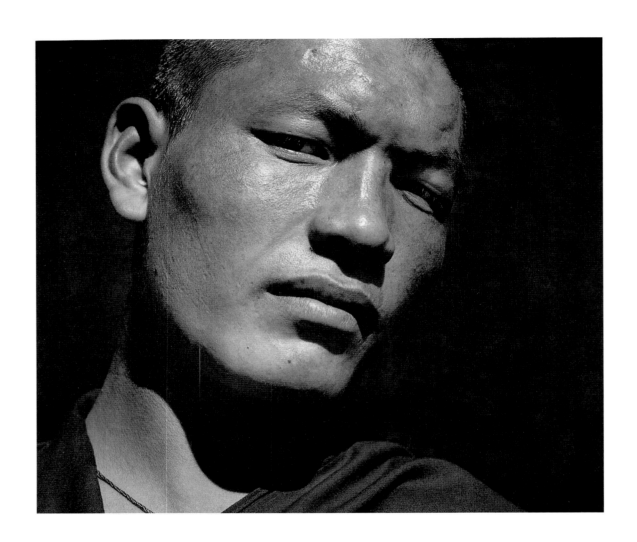

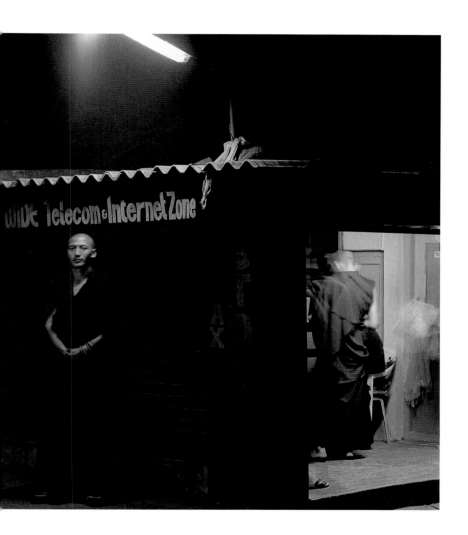
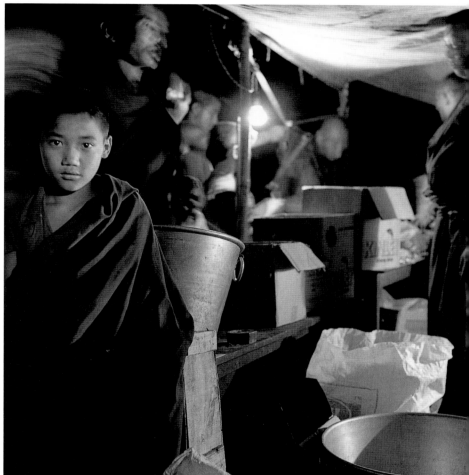

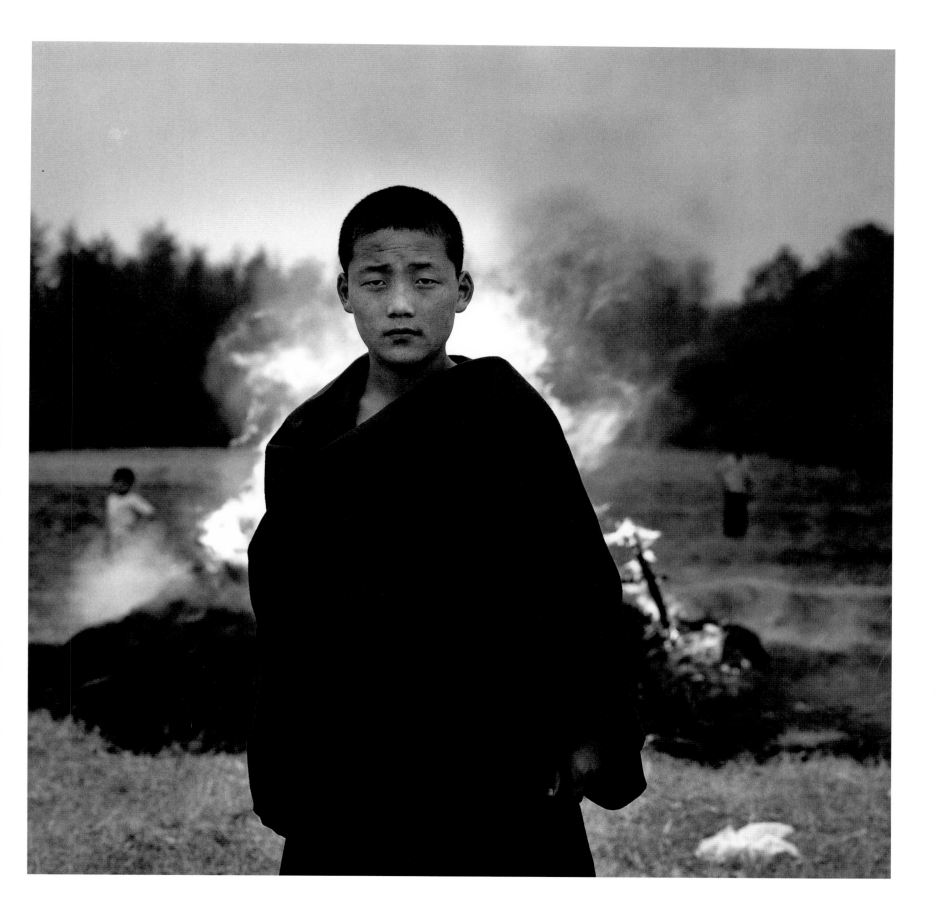

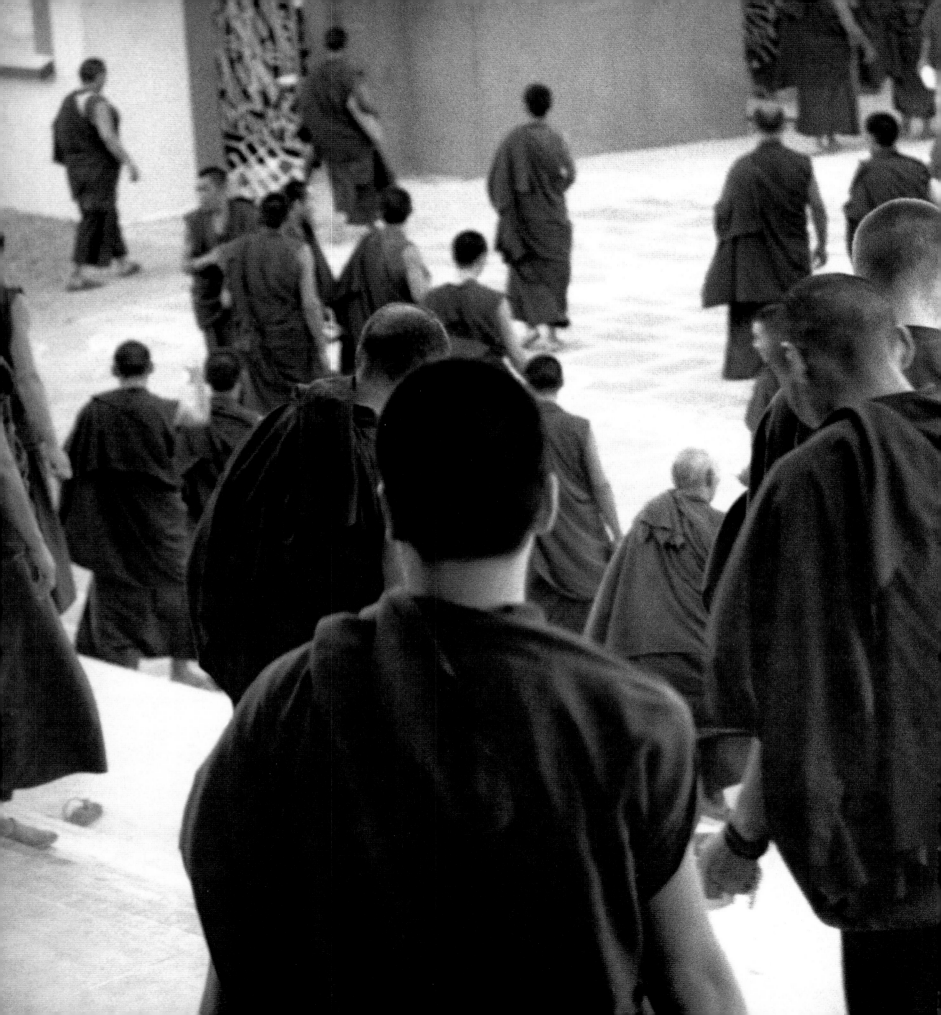

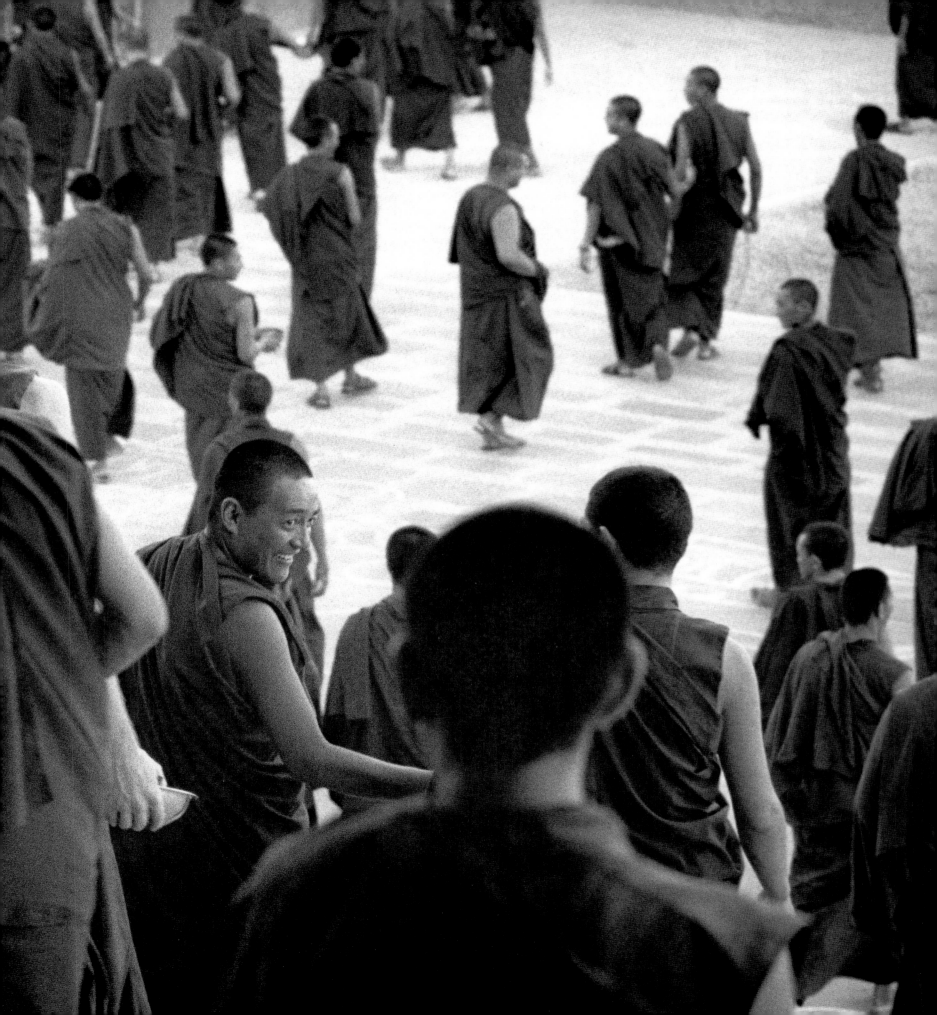

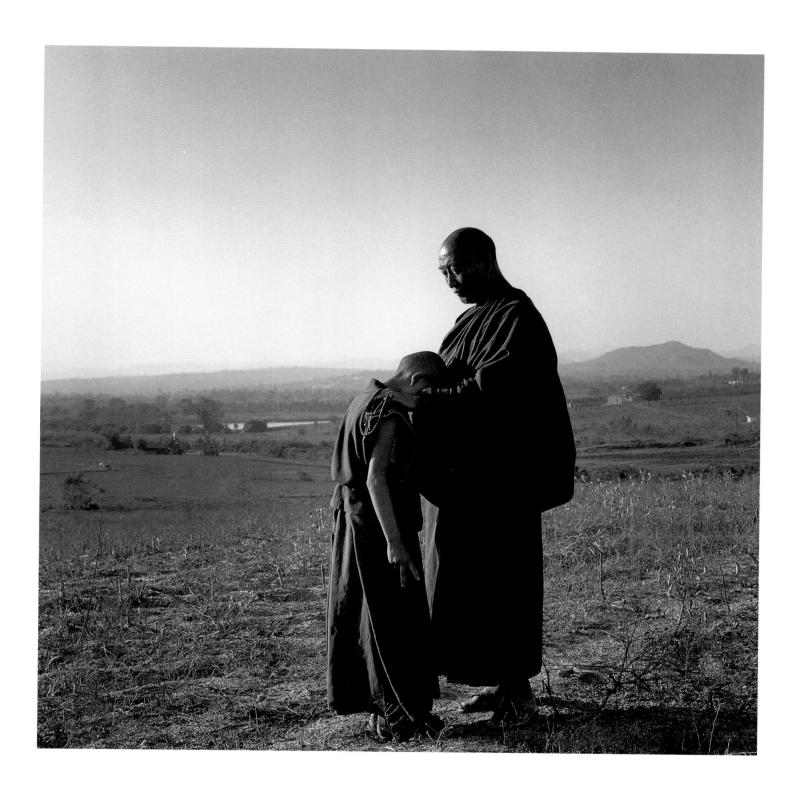

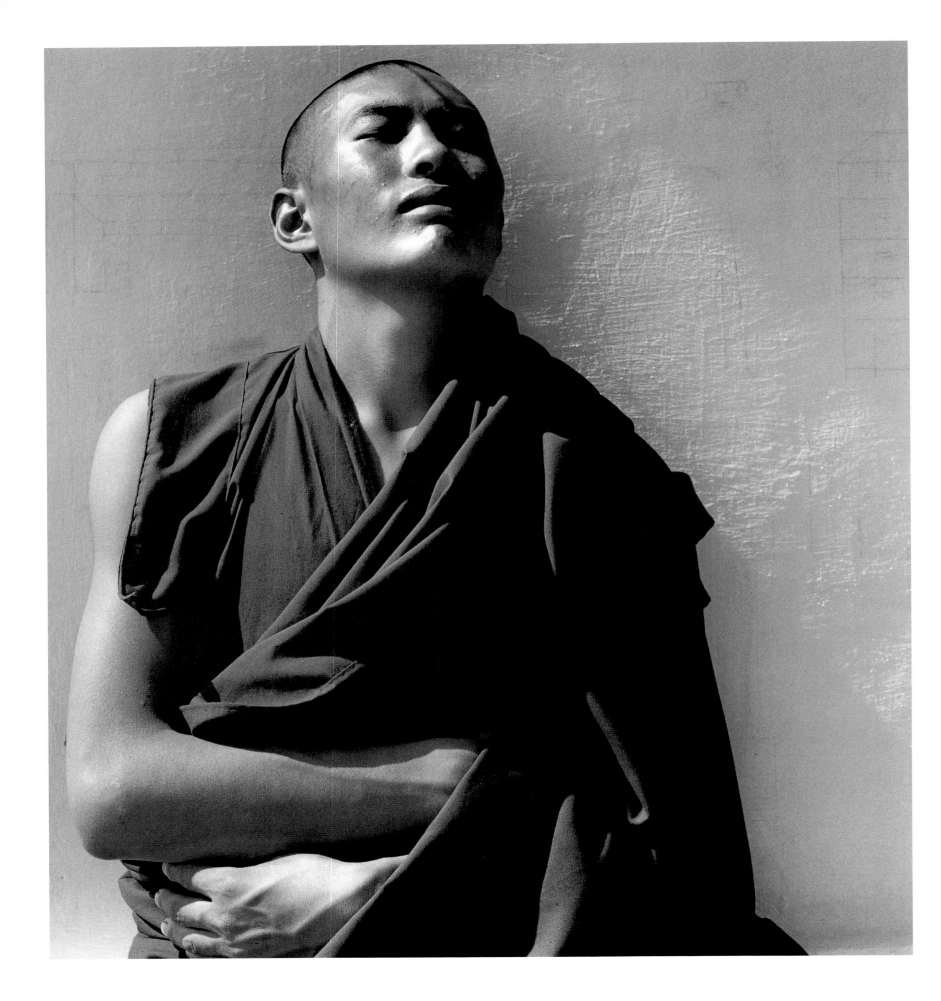

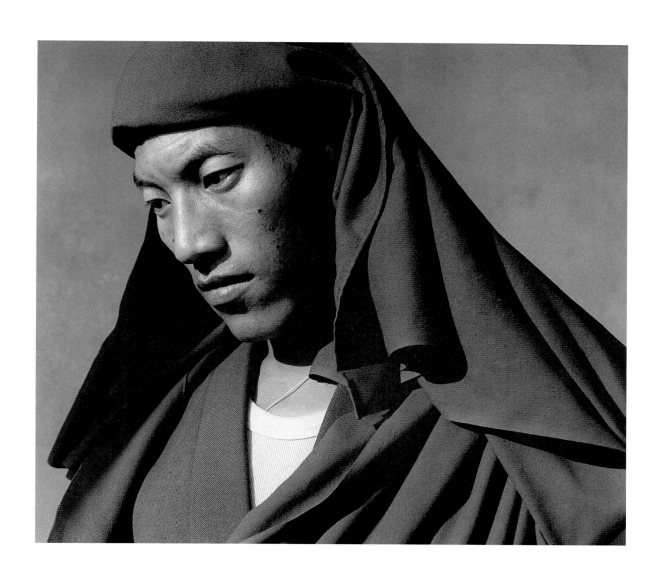

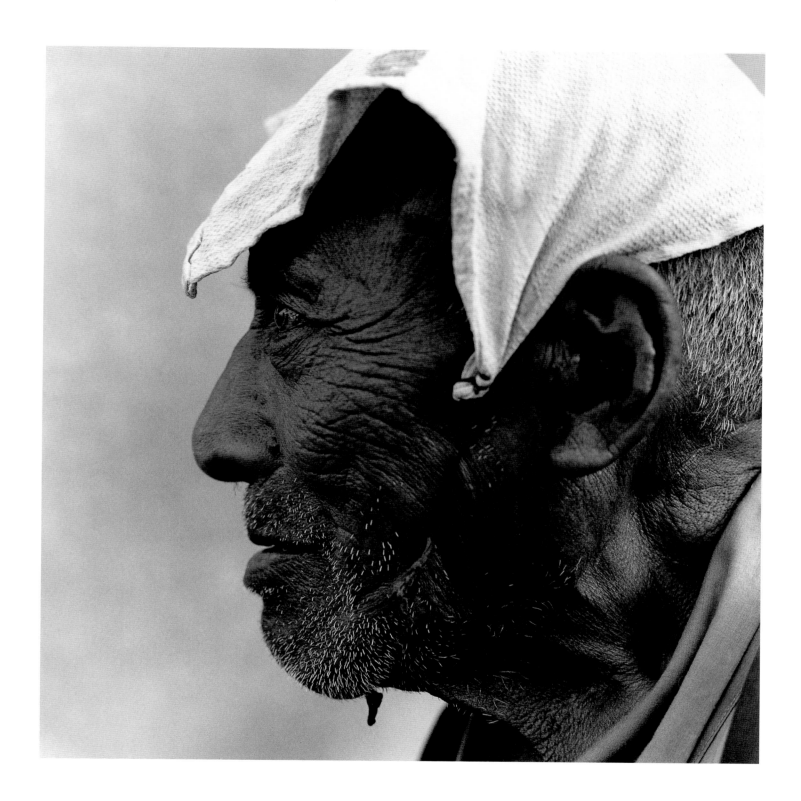

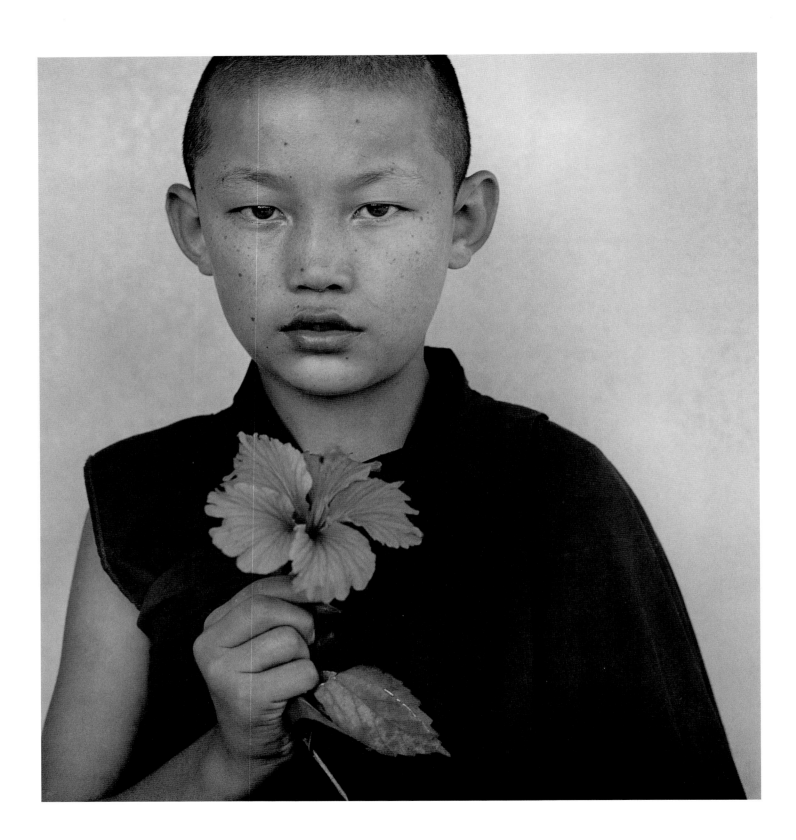

Regardless of how long spent living together,

Good friends and relations must someday depart.

Our wealth and possessions collected with effort

Are left far behind at the end of our life.

Our mind, but a guest in our body's great guest house,

Must vacate one day and travel beyond—

Cast away thoughts that concern but this lifetime—

The Sons of the Buddha all practice this way.

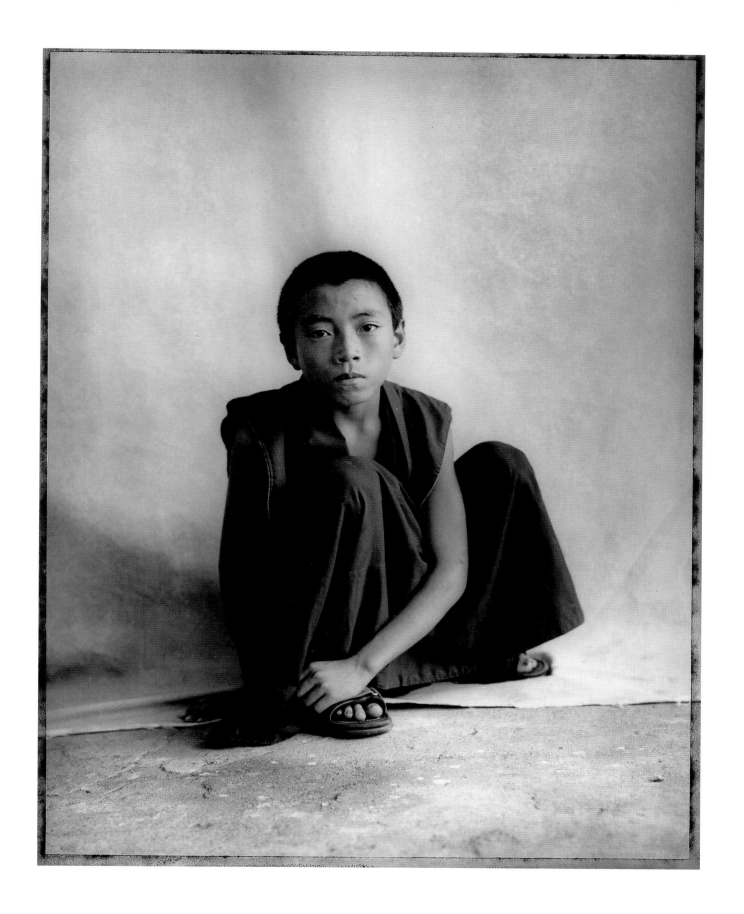

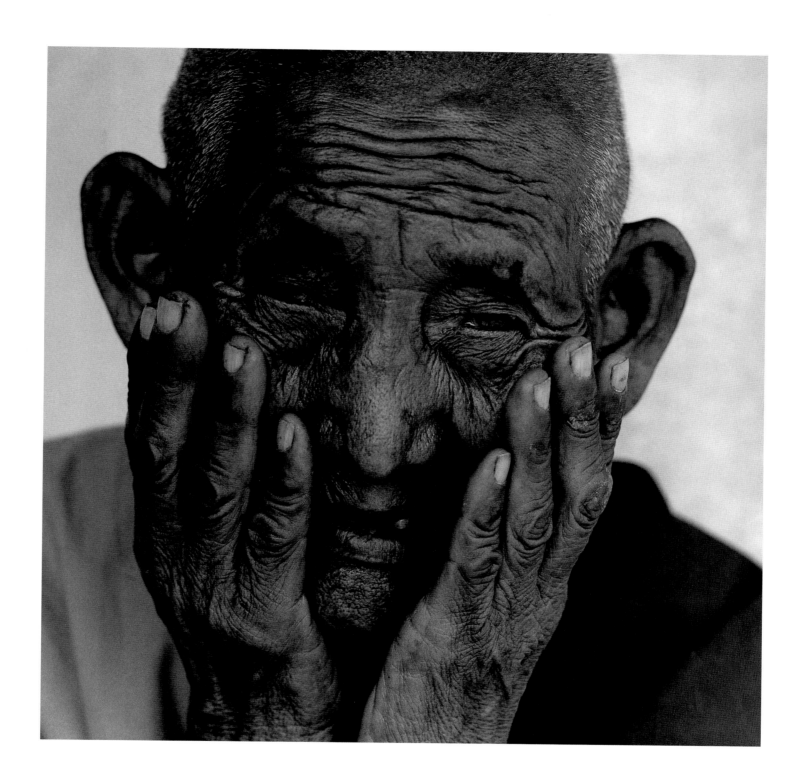

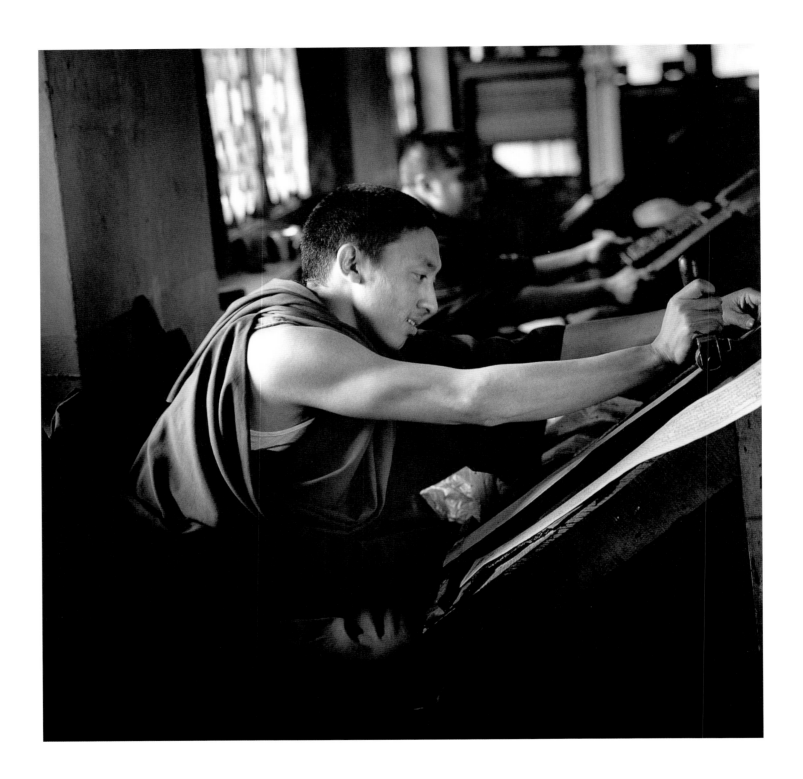

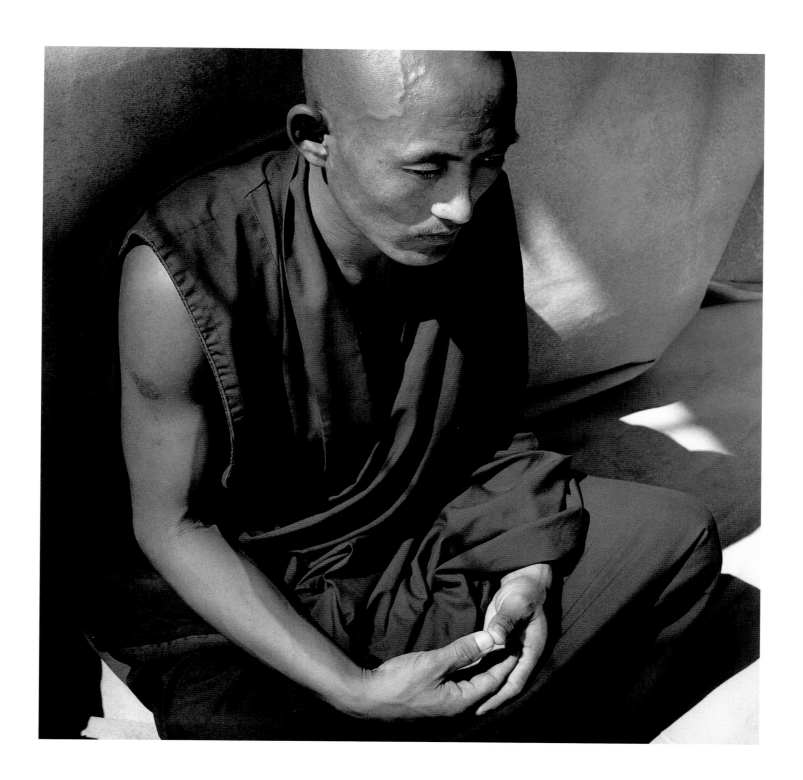

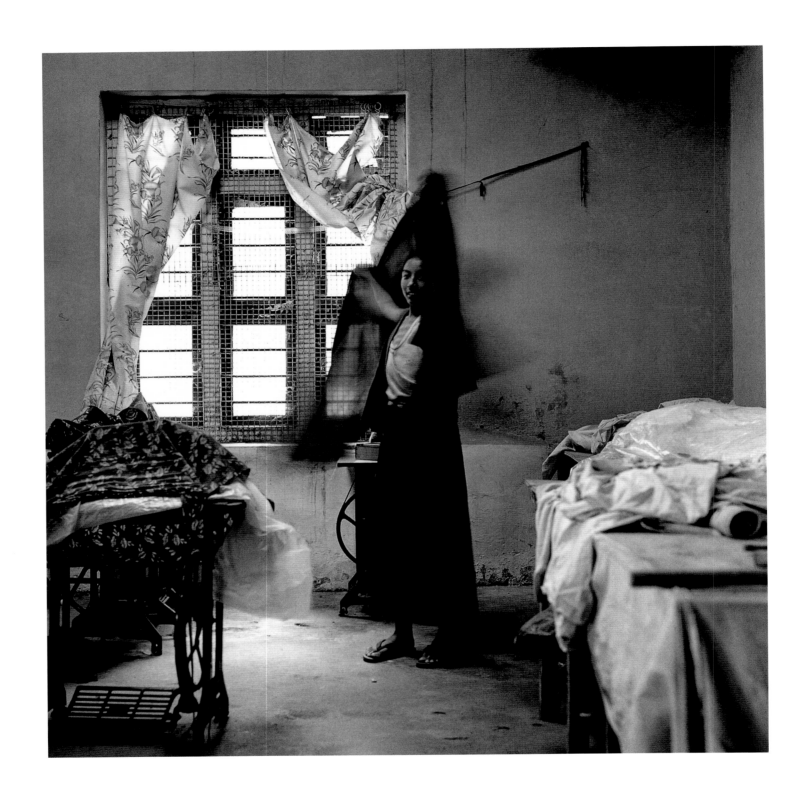

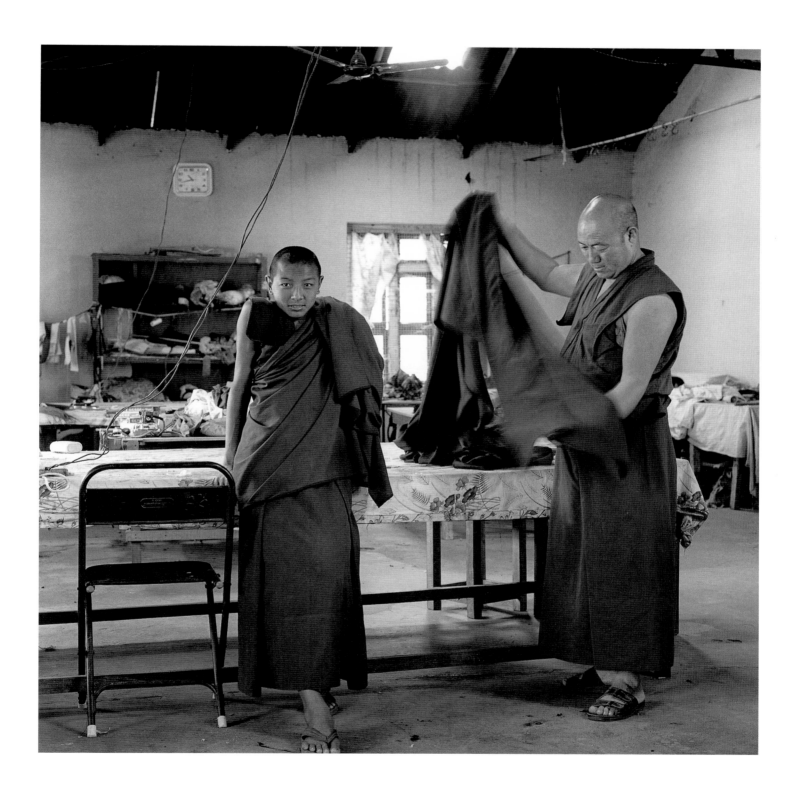

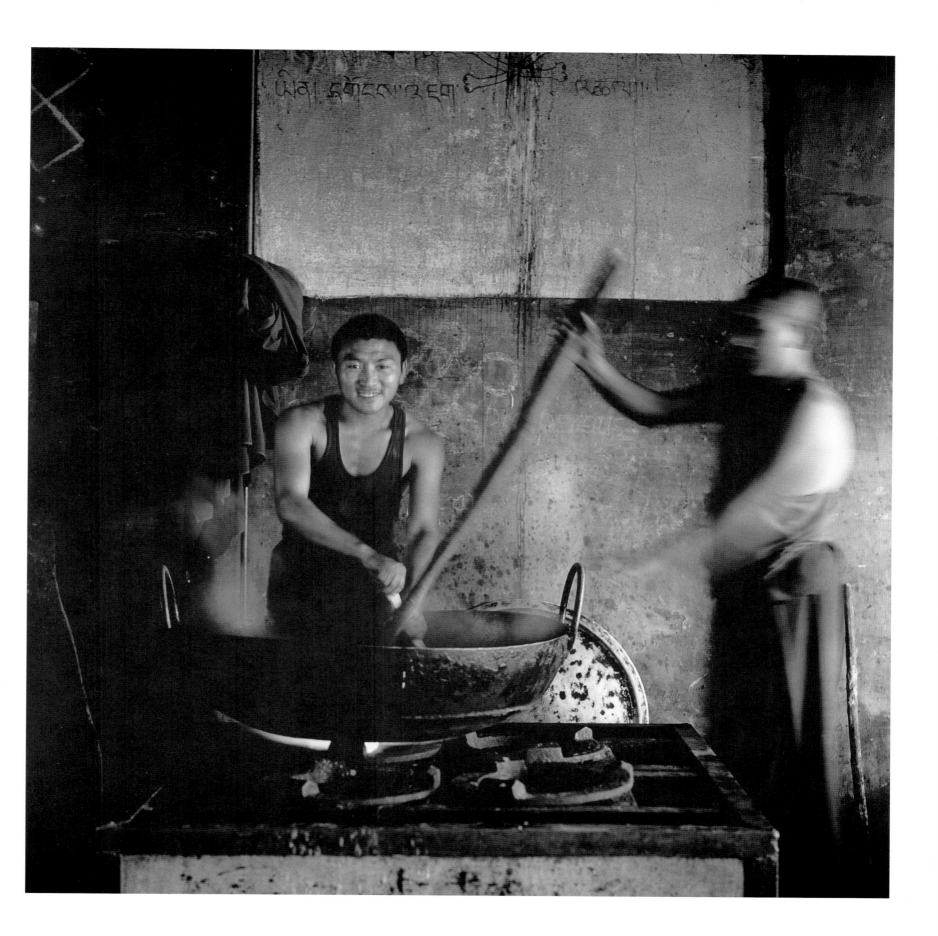

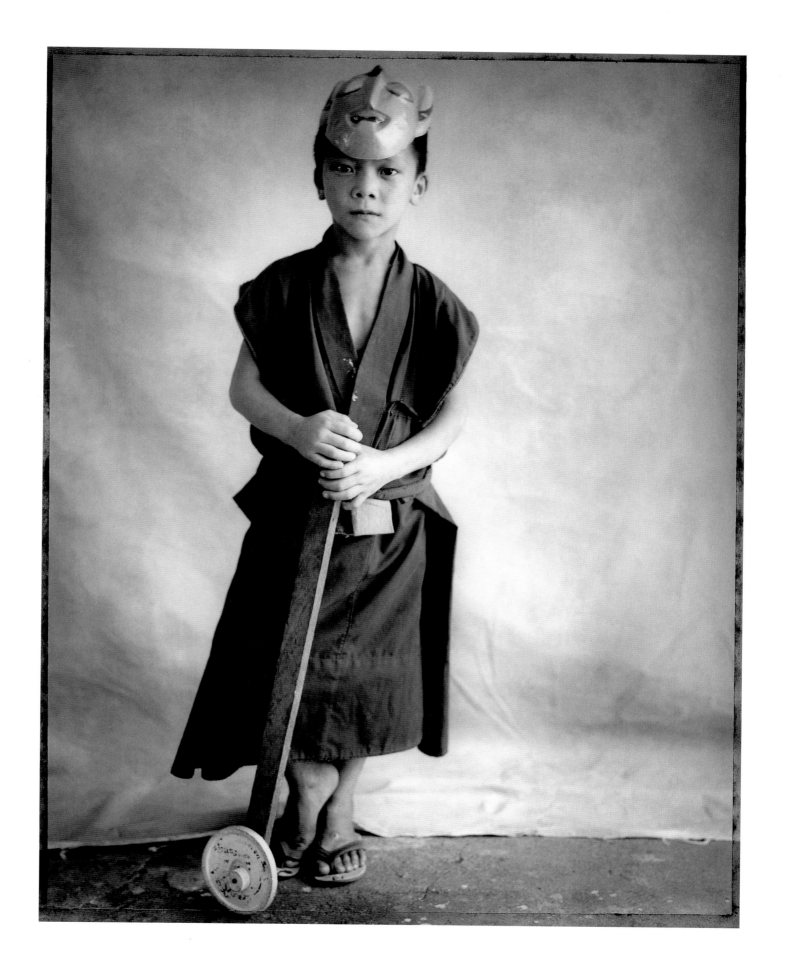

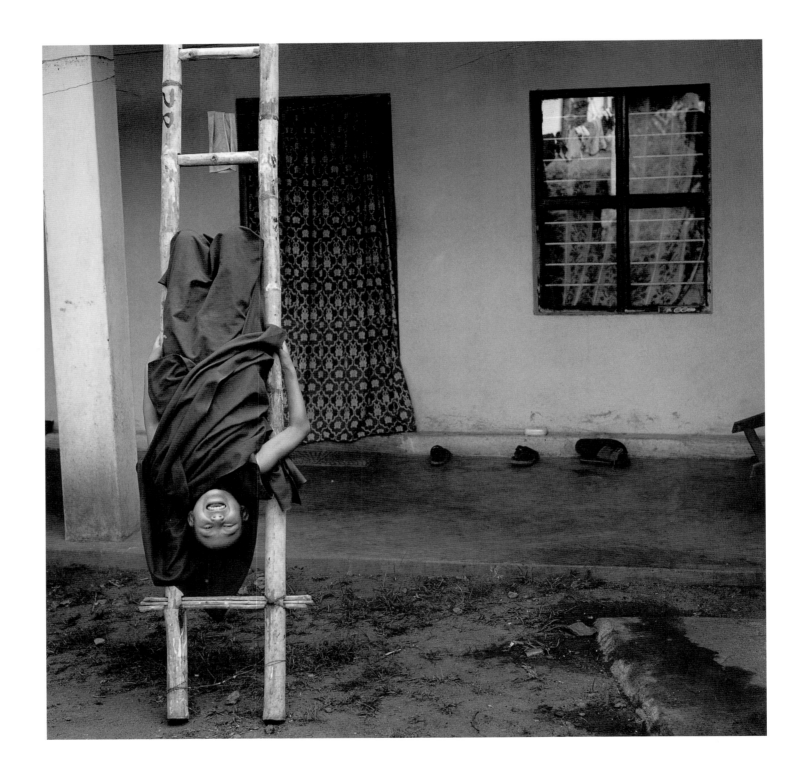

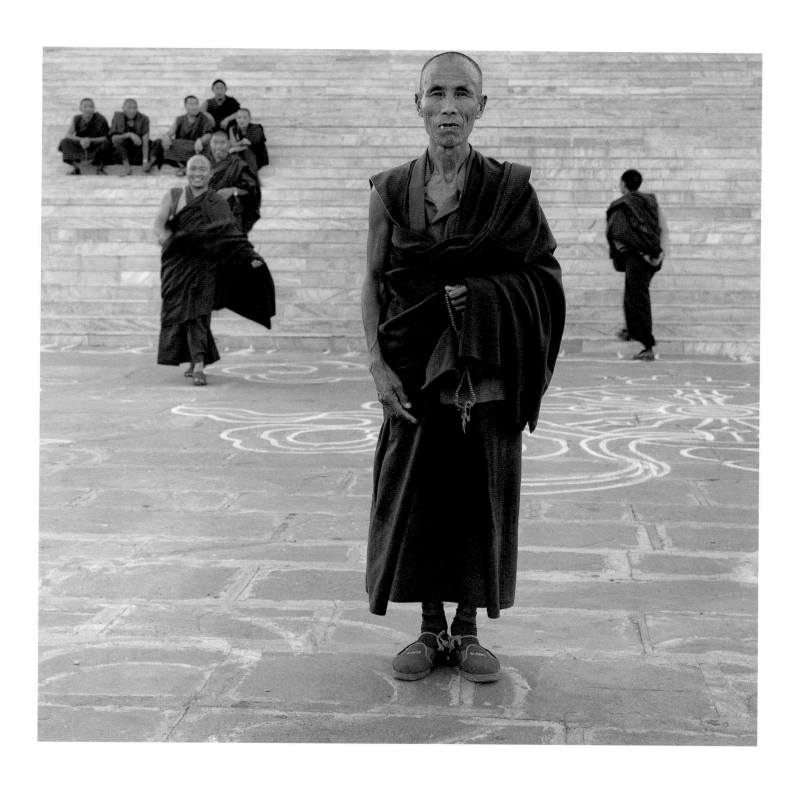

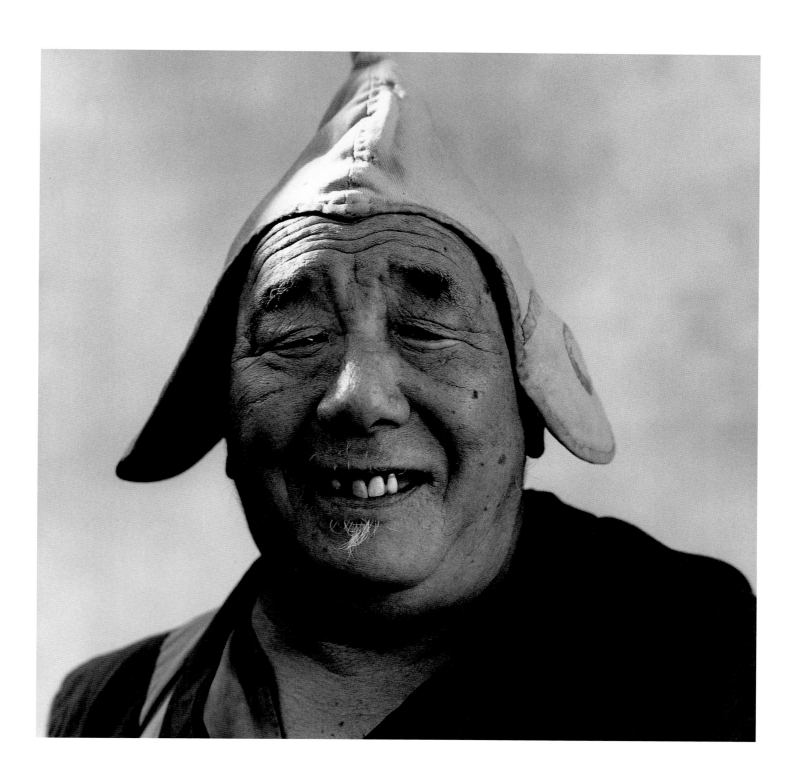

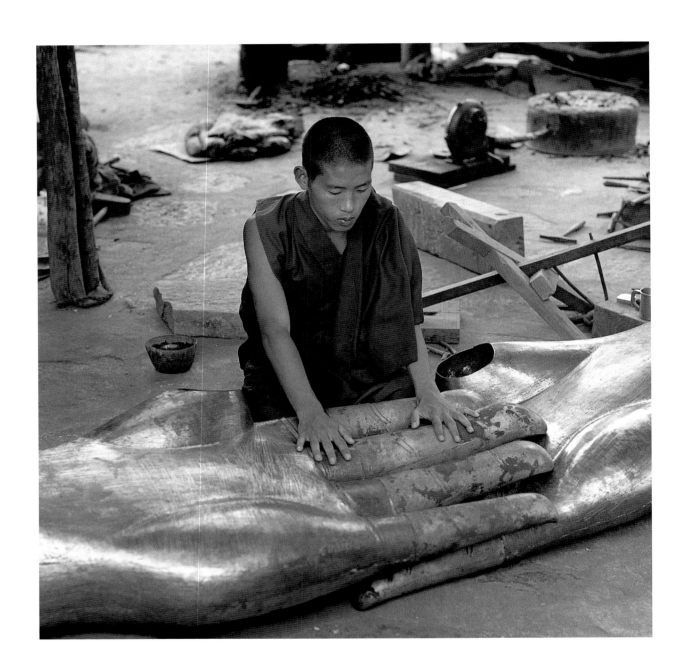

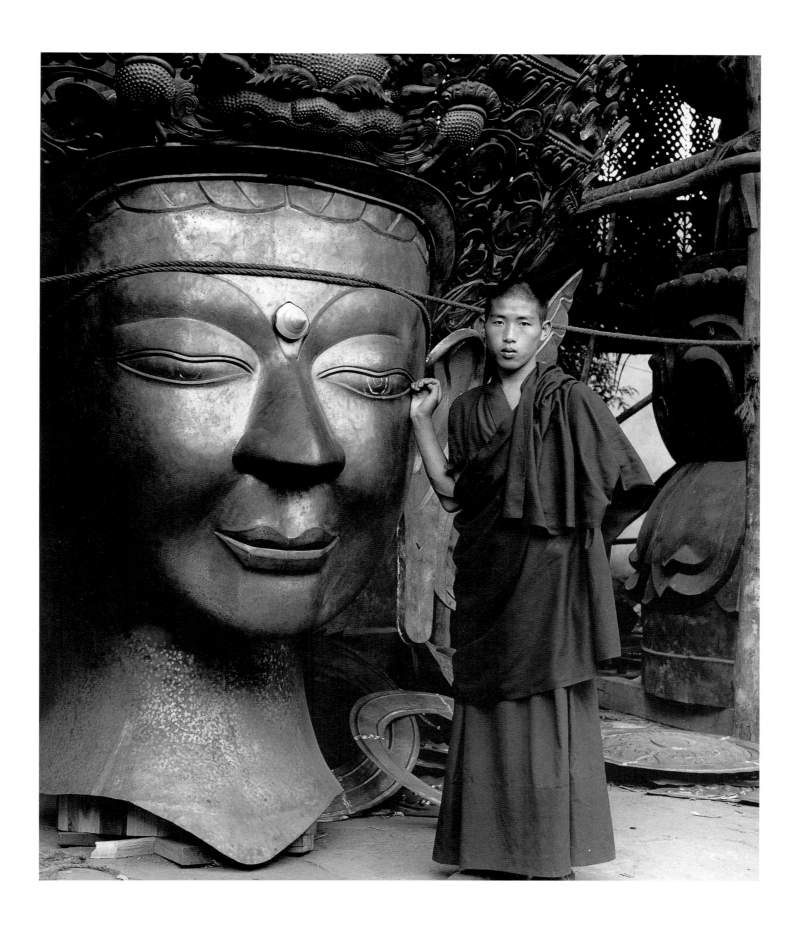

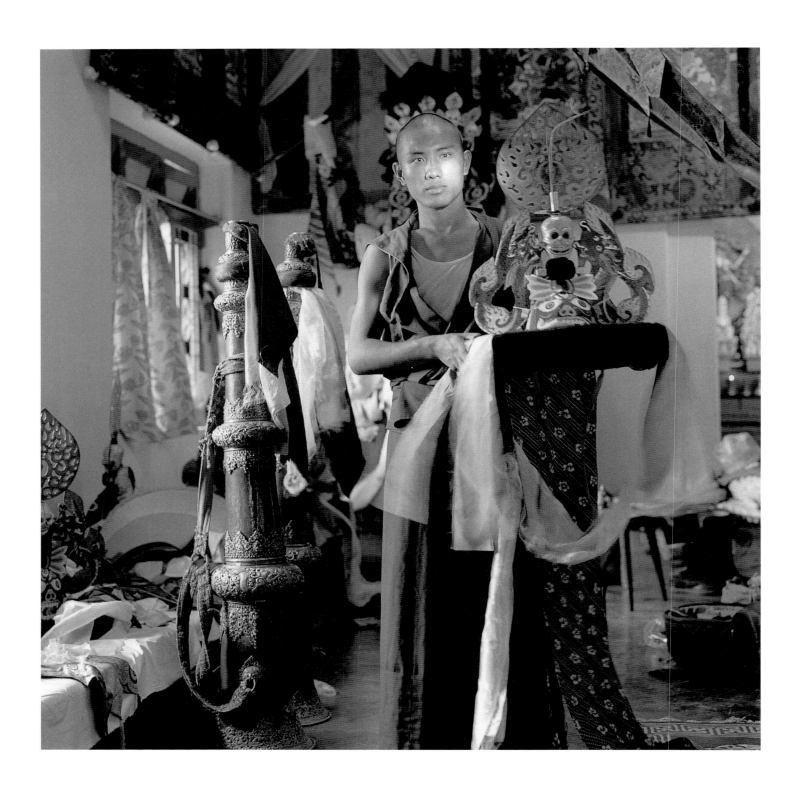

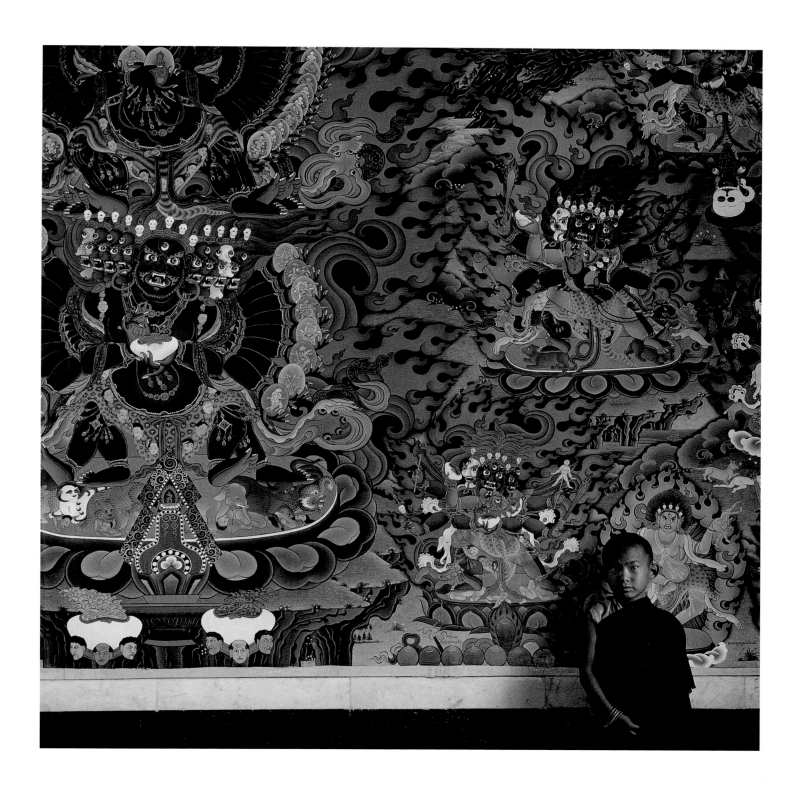

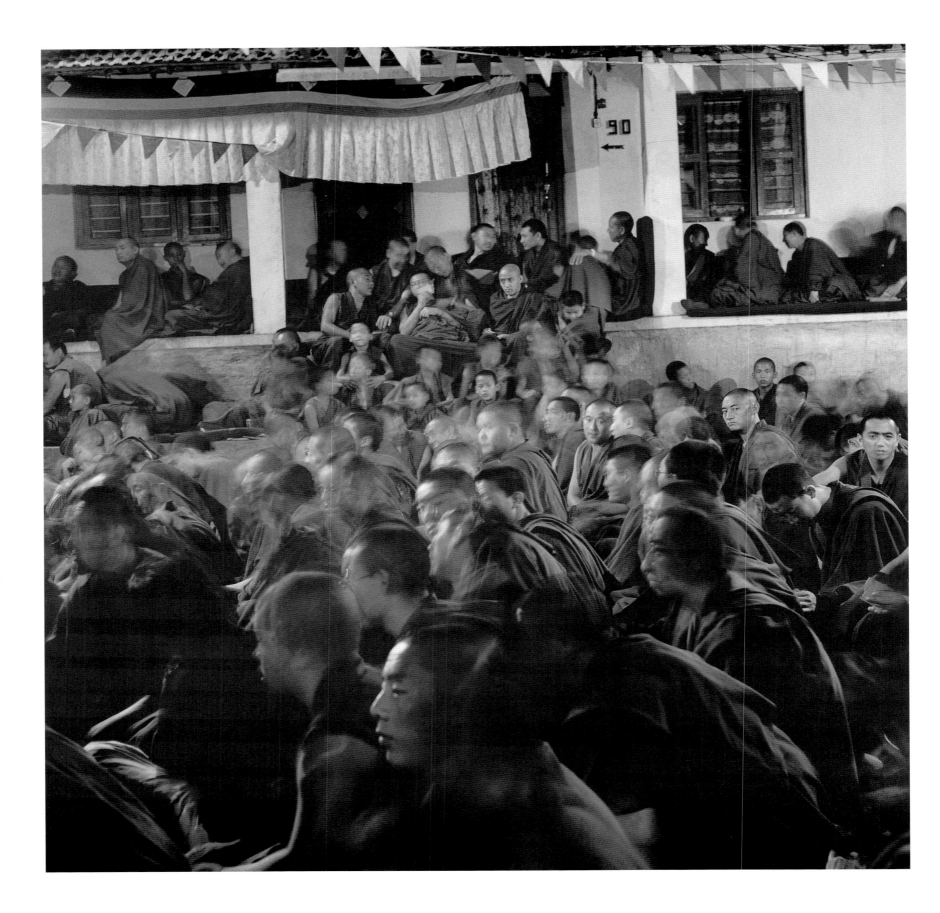

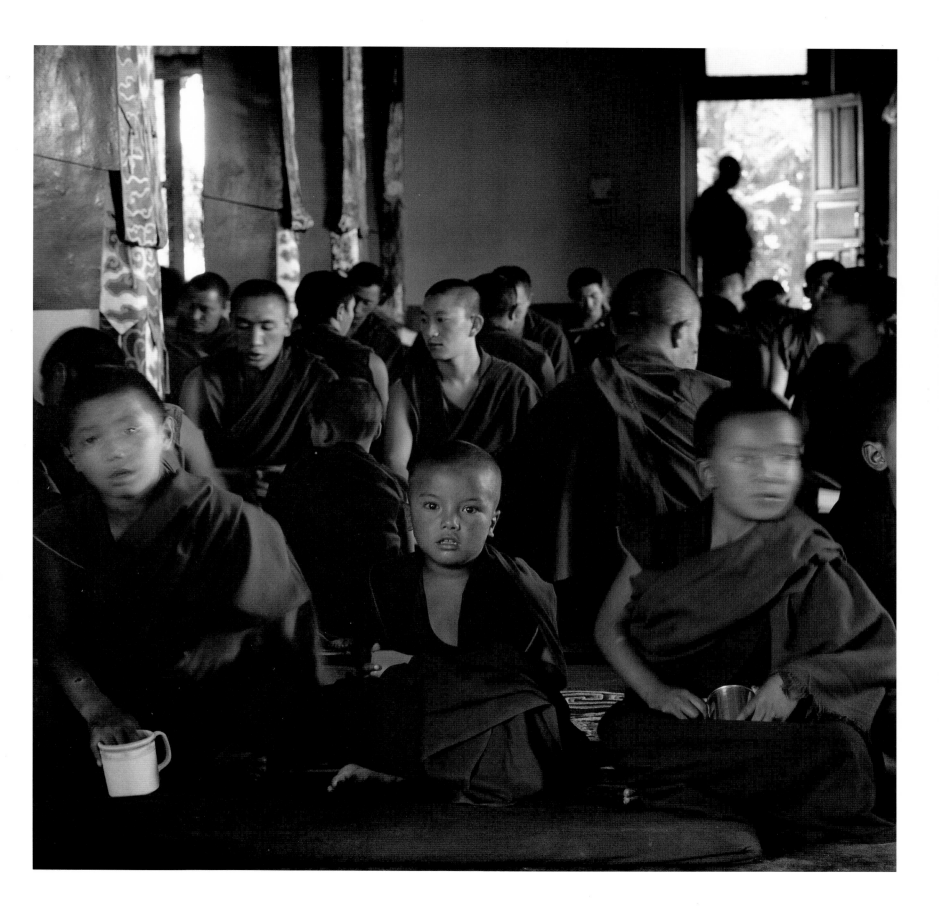

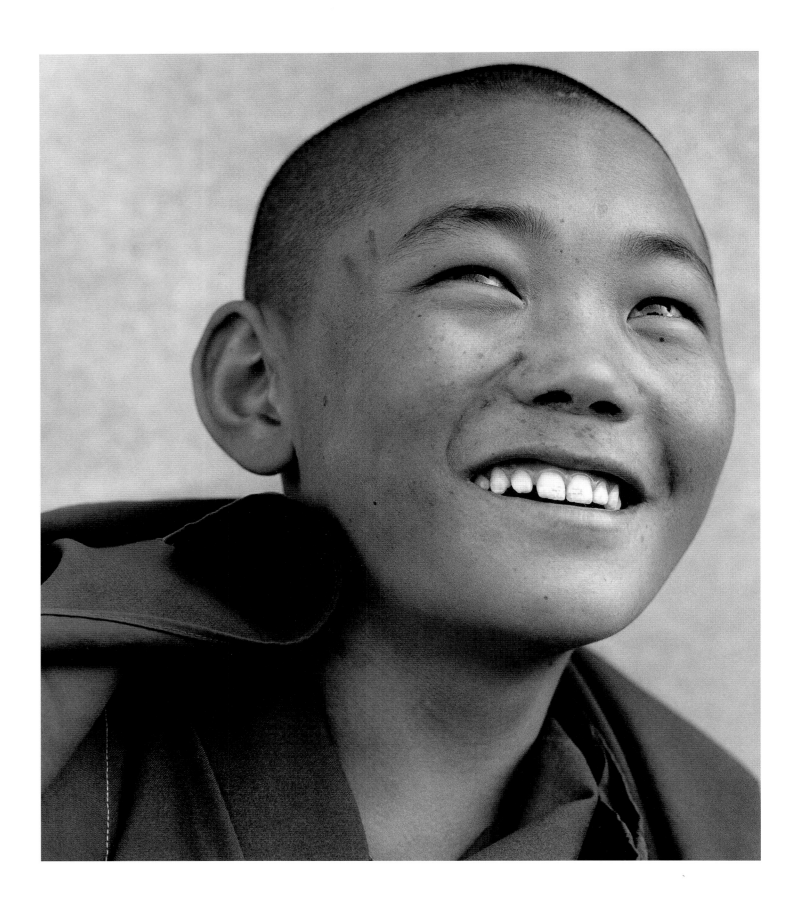

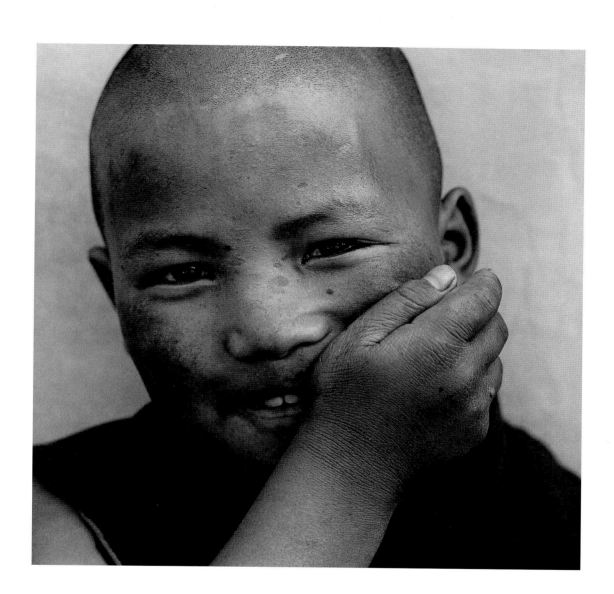

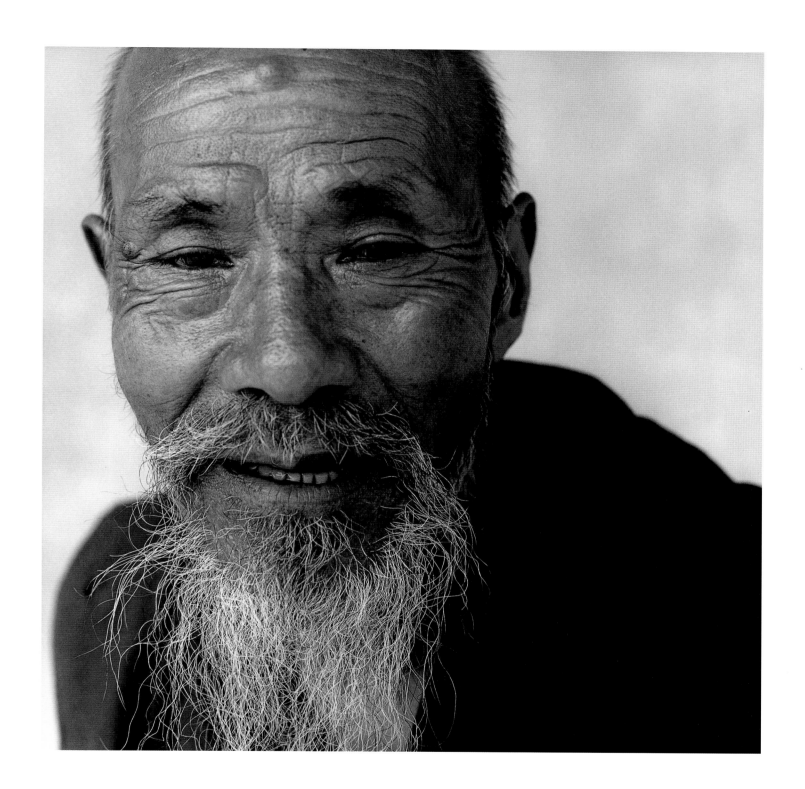

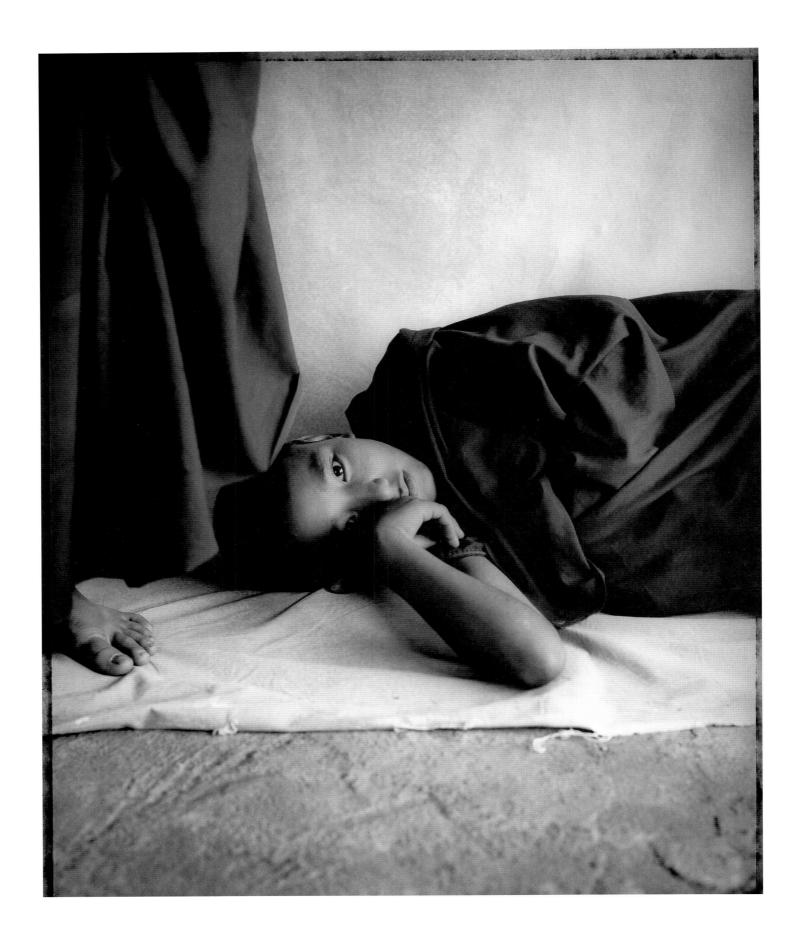

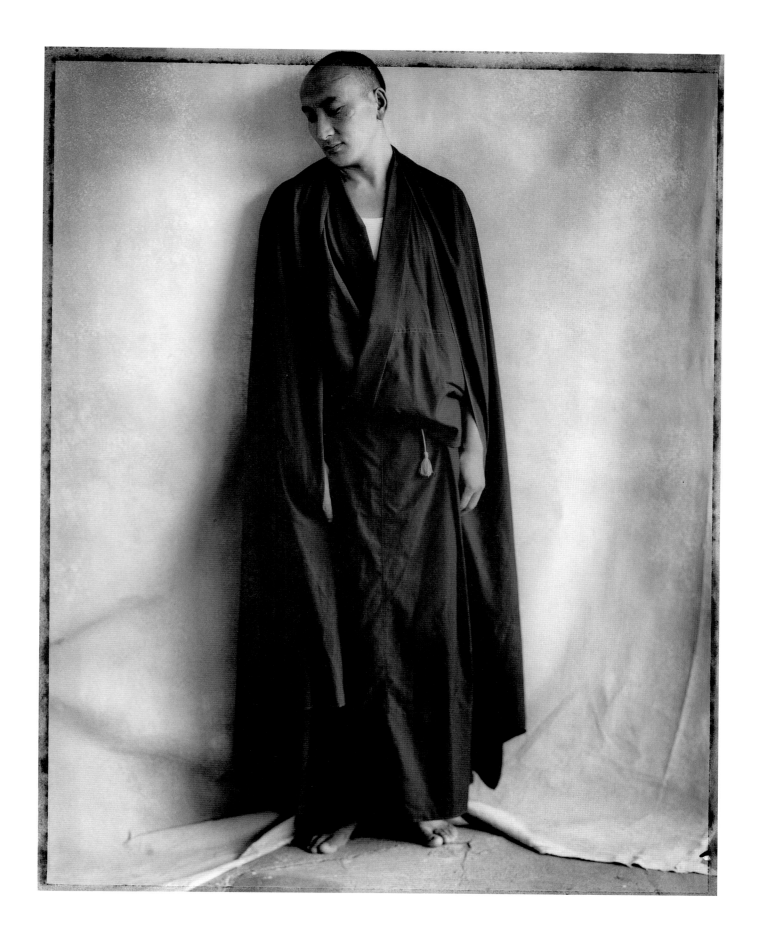

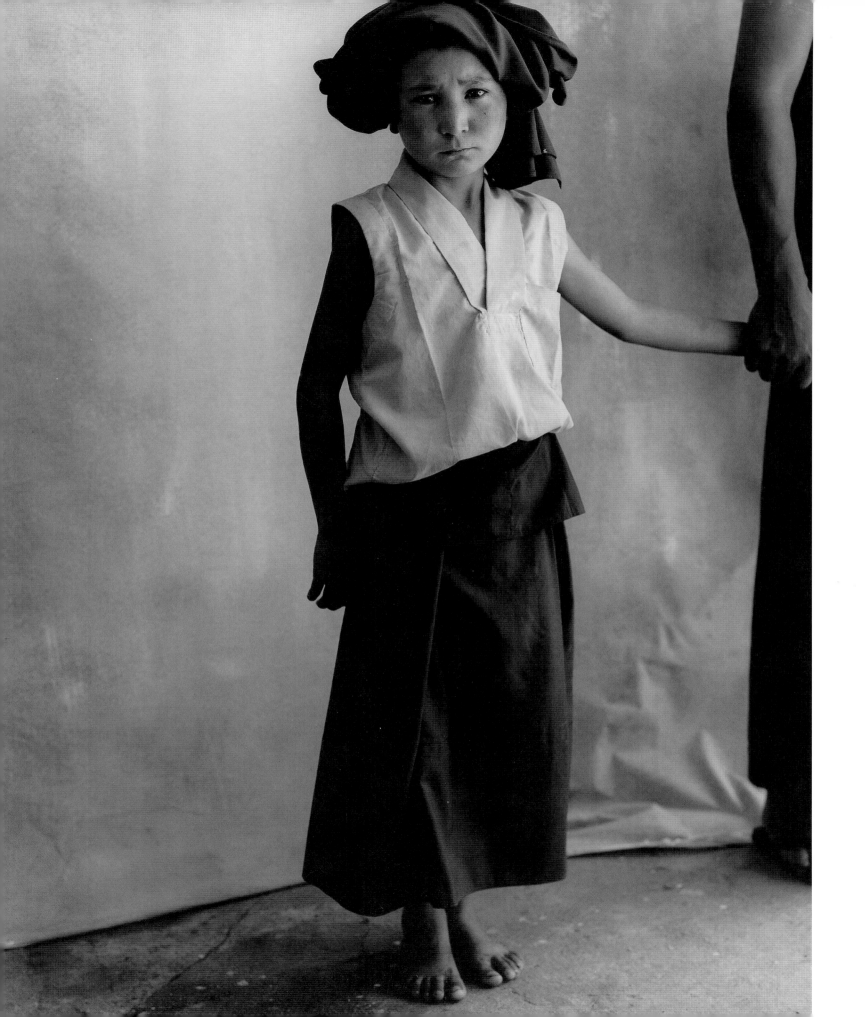

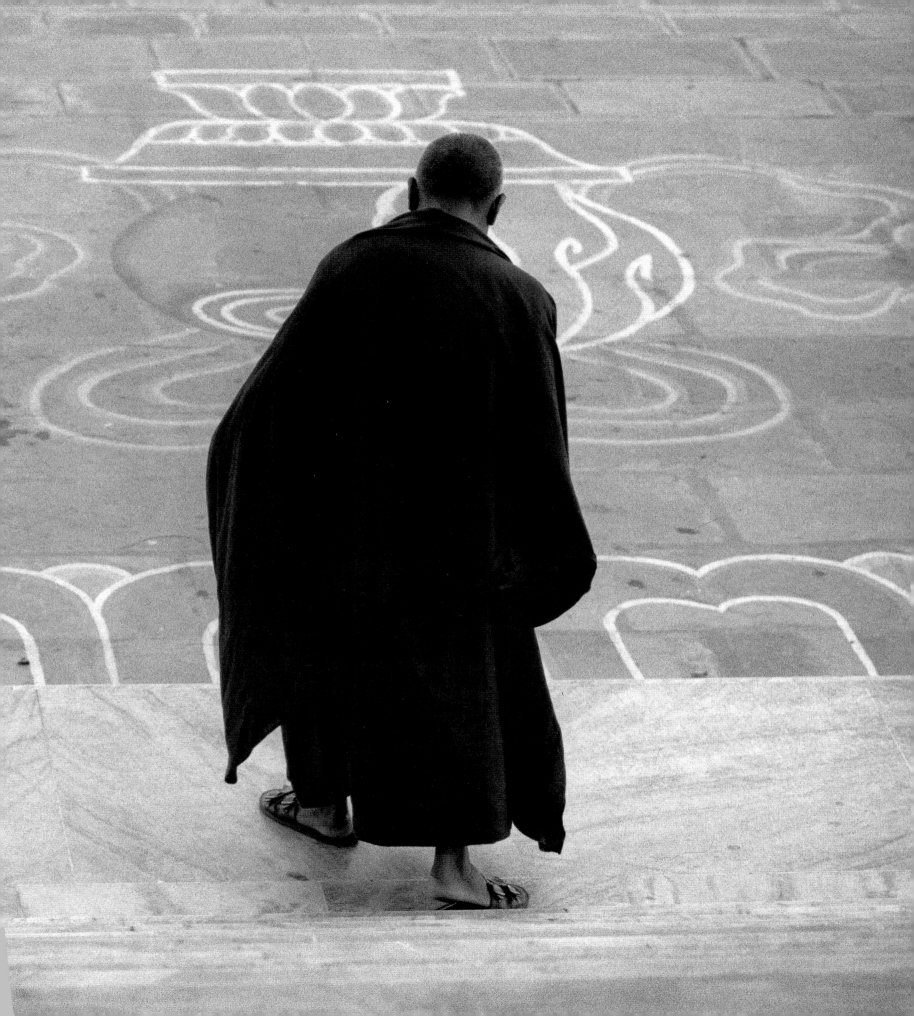

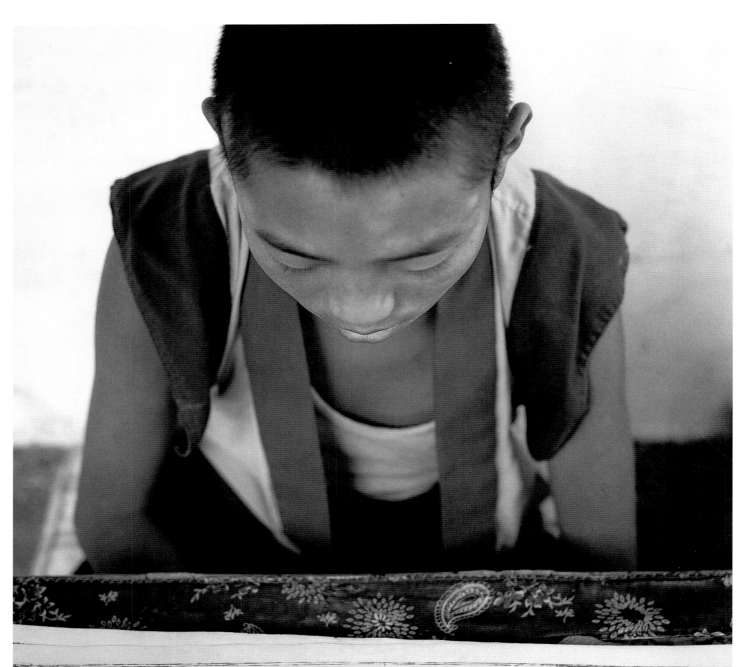